FEININGER'S CHICAGO, 1941

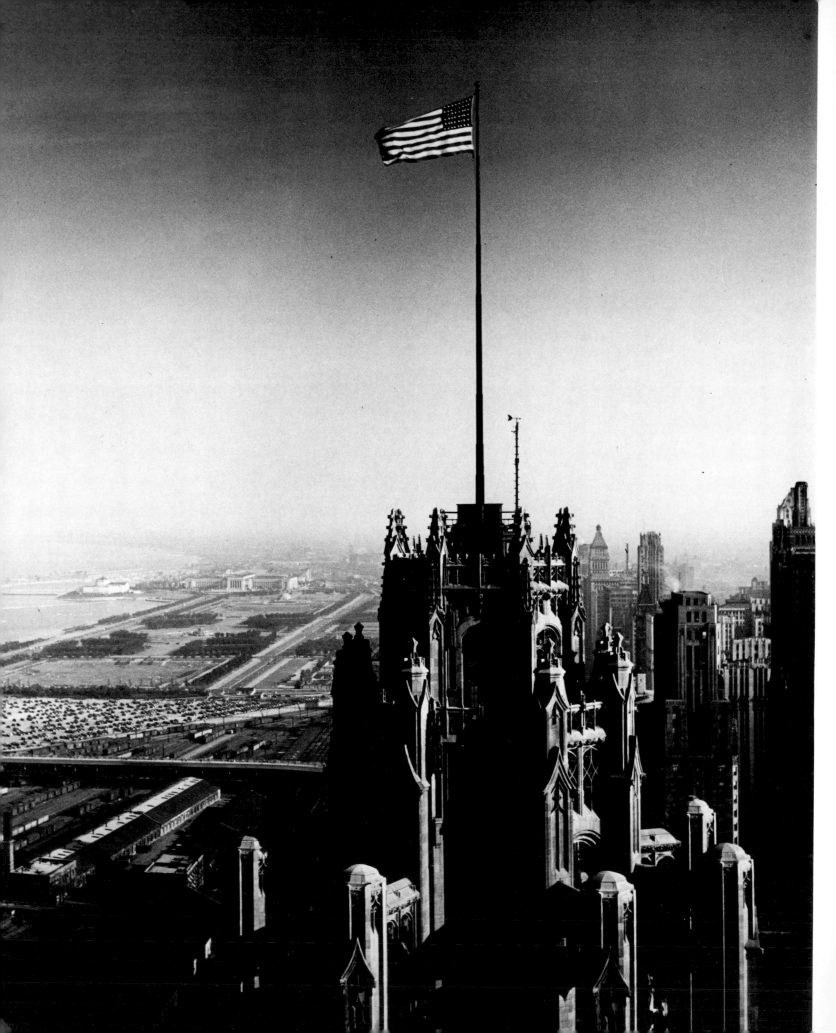

Andreas Feininger

FEININGER'S CHICAGO, 1941

Dover Publications, Inc.

New York

The photographs on the following pages were produced on assignment for LIFE Magazine, Copyright © 1948 by Time Inc., and are reproduced here by courtesy of Time Inc.: 14, 52/53, 56/57, 58–61, 66/67.

Frontispiece: The Chicago Tribune Tower.

Published in Canada by General Publishing Company,
Ltd., 30 Lesmill Road, Don Mills, Toronto, Ontario.
Published in the United Kingdom by Constable and
Company, Ltd., 10 Orange Street, London WC2H 7EG.

Feininger's Chicago, 1941 is a new work, first published
by Dover Publications, Inc., in 1980.

International Standard Book Numbers:
0-486-23991-8 (Paperbound)
0-486-24007-X (Clothbound)
Library of Congress Catalog Card Number: 80-66135

Manufactured in the United States of America
Dover Publications, Inc.
180 Varick Street
New York, N.Y. 10014

Introduction

This book shows you how I saw Chicago forty years ago. The time was 1941. We — my wife Wysse and I — were living in New York, and things were different then, remember? A subway ride was a nickel, *The New York Times* three cents and the *Daily News* two. We shunned the Fifth Avenue buses because the fare was ten cents as against only five on all the other bus lines in the city. We had very little money then — I had just quit photographing for a well-known picture agency because the job paid only twenty dollars a week — but in those times, a little went a long way.

The idea to do a picture essay on Chicago came to me after I had successfully sold a story on New York to *Life*. I had discussed the matter with Wilson Hicks, then picture editor, who, in essence, said: why not? So off we went, Wysse and I, to Chicago.

We drove, because we wanted to see as much of the country as possible. We had been in America only a little over a year. Everything was different from what it had been at home in Stockholm, fascinating and new. We had bought a secondhand Pontiac coupe with a powerful straight-eight engine, sweeping fenders and headlights reminiscent of those on old-fashioned locomotives; it looked like the essence of an automobile, a real road-machine, not like a pretentious shoebox with wheels.

The highways, too, were different then. No speed limits on the open roads, and on the Pennsylvania Turnpike we hit ninety. The rest of the road, well, that was another matter — narrow, twisting and bumpy. But driving in those days gave you a feeling of the country and of freedom and adventure which people traveling in modern automatic-shift, air-conditioned, soft-sprung sedans on dead-flat interstate highways will never know. Twenty-two strenuous but exhilarating hours later we arrived at our destination and checked in at the Stevens Hotel.

My knowledge of Chicago was scant: I knew that it was notorious as Boss Kelly's city; that is was the biggest food, trucking and railroad center in the U.S., with a vast network of tracks shared by twenty major railroads; that it included an enormous complex of stockyards, cattle pens and packing plants made famous everywhere through household

words like Armour and Swift; that it had "the Loop," a downtown area encircled by the turnaround of a great elevated rapid-transit system; that it was the home of the Wrigley Building and the Chicago Tribune Tower and the Marshall Field Department Store and the Field Museum of Natural History and a stadium called Soldier Field and the Art Institute and an aquarium and a planetarium and numerous drawbridges across the Chicago River, which allegedly had gotten its name from *chickagou* which means "place of wild onions" in the language of the Pottawattomie Indians. I also knew that it had an aging, dark and noisy business district, a fabulous drive along Lake Michigan, and what were said to be America's worst slums. It seemed to be a brawny, brawling city of enormous contrasts and pictorial opportunities, and I couldn't wait to document its fascinating features.

The pictures you are going to see represent the essence of my stay—highlights which will show you many of the most interesting views and most typical aspects of one of the world's most dynamic cities as I experienced it. I never intended this to be a comprehensive study of Chicago. As a result, many Chicagoans may look in vain for certain views which they remember from their youth. But many such views would either have been not particularly characteristic of Chicago or would have been pictorially insignificant and therefore disappointing to anyone not emotionally attached to them. Instead, what I had in mind was to draw a portrait of Chicago which, because of space limitations inherent in any magazine article or picture story, contained only features which were unmistakably Chicago.

To achieve this goal, I had over most photographers attempting a similar task the advantage that I had never been in Chicago before and therefore was able to see the city with fresh and unbiased eyes. On the other hand, being familiar with other great metropolises, such as Berlin, Paris, Stockholm and New York, I was in a position to recognize aspects which were different from those I had encountered before, aspects which were unique to Chicago. It was these aspects which I intended to show.

One of the first things I do whenever I come to a new big city is to get myself a street map. Having a rather analytical mind, I see in any map a friend and adviser which "talks" to me, telling me innumerable facts about the subject it represents. Not only does a map show me how to get from place to place, but it also shows me specific, potentially interesting features and sights which I might otherwise have missed—the location of markets, rail terminals, the harbor and docks, parks and beaches, public buildings, bridges, monuments and so on. Furthermore, since any map shows the points of the compass, it lets me know when specific streets or buildings will be in the sun and when in shade, and the hours when I can expect to encounter the raking sidelight I may need to bring out the relief in the facade of a certain building or the backlight that creates the glitter of sun on water. And finally, a street map helps me to pinpoint my photographs in relation to the city as a whole and aids me in captioning my shots.

For twenty days, armed with a good street map, Wysse and I explored Chicago in depth. We went to the tops of tall, windswept towers—not for nothing is Chicago known as the "Windy City"—for overall shots and bird's-eye views (frontispiece, pp. 14, 15, 24,

25). We watched the majestic rise and descent of ponderous drawbridges spanning the Chicago River (pp. 24–29). We walked in darkness under the iron roof of the el amid deafening noise — trains thundering overhead, car, truck and bus engines roaring, people shouting to one another to make themselves heard, taxis honking, radios blaring, street vendors hawking their wares (pp. 37–43). We basked in the sun on Lake Michigan's beaches where we joined the festive Sunday crowd (pp. 76 and 77). We admired old-fashioned steam locomotives at Dearborn and diesel-powered streamliners at Union Station (pp. 54–57). We documented the sprawling South Side slums (pp. 60–67) where we found the ultimate in horror in the dilapidated yet still inhabited tenement once known as the Golden Flats (pp. 66 and 67)—a building erected before the turn of the century standing only a few feet away from the New York Central railroad tracks where trains thunder past and shake its rotting foundations two hundred times each day. We braved the stench of the stockyards (pp. 72 and 73) where, at the Saddle and Sirloin Club, we were treated by our kindly host to the choicest steaks we ever tasted. We enjoyed the splendor of the Lake Shore Drive (pp. 10–14) and the wealthy North Side community. We poked into the service alleys of the downtown area which, with their loading platforms and towering fire escapes, are unique to Chicago (pp. 48–51). We visited the produce markets and truck terminals and the flea market on Maxwell Street in the ghetto (pp. 68–71).

We worked from dawn to dusk for twenty days, then drove back to New York where I developed my films, printed my negatives, and presented my picture essay to the editors of *Life*. But, to my great disappointment, it never made the magazine. Those were tumultuous times; Pearl Harbor was only a few months away, and more important picture stories took precedence. Without the courage and interest of Dover Publication's far-sighted president no one would ever have seen these photographs. Thank you, Hayward Cirker!

For those of you who are interested in the technical aspects of photography, here are a few remarks. I took all my pictures with a 2¼-x-2¼-inch twin-lens reflex camera, a Rolleiflex. The film was Kodak Super-XX, the developer Kodak D-76. Altogether, I exposed 26 rolls of film for a total of 312 shots from which I subsequently chose the pictures for this book.

Today, most photographers would probably use a 35-mm single-lens reflex camera for this kind of work. But I still believe that a 2¼-x-2¼-inch twin-lens reflex camera is more suitable—and suitability for the job it has to do is, in my opinion, a camera's most important requirement, far more consequential than brand name, popularity or price. And I believe that, in my case, the twin-lens reflex was more suitable because its larger film and viewfinder size enabled me to see more clearly what I had in front of me, to compose more carefully and, in the end, to obtain pictures which were sharper, less grainy and more finely detailed.

Next to suitability of the camera, the most consequential prerequisite for making effective photographs is, in my experience, the ability on the part of the photographer to develop what I call a "photo-eye"—to be able to see in terms of light and shadow, black

and white, contrast, color, perspective and scale . . . to watch out for and avoid unsuitable backgrounds . . . to consider the quality and direction of the incident light. Because, in this age of automation and services, the computerized camera does most of our "technical thinking" for us and a commercial photo-finisher does the rest, photographers today can acquire whatever technical knowledge they need by studying the manufacturer's instructions for use which accompany every new camera and every roll of film. Making technically perfect photographs is no longer difficult—but let's never forget that a technically perfect photograph can still be the world's most boring picture. What counts are interest and involvement in the subject, an understanding of the characteristics of the photographic medium, and taste and imagination on the part of the photographer, because the "guidance system" of any camera are eyes and brain.

New Milford, Connecticut
1980 ANDREAS FEININGER

FEININGER'S CHICAGO, 1941

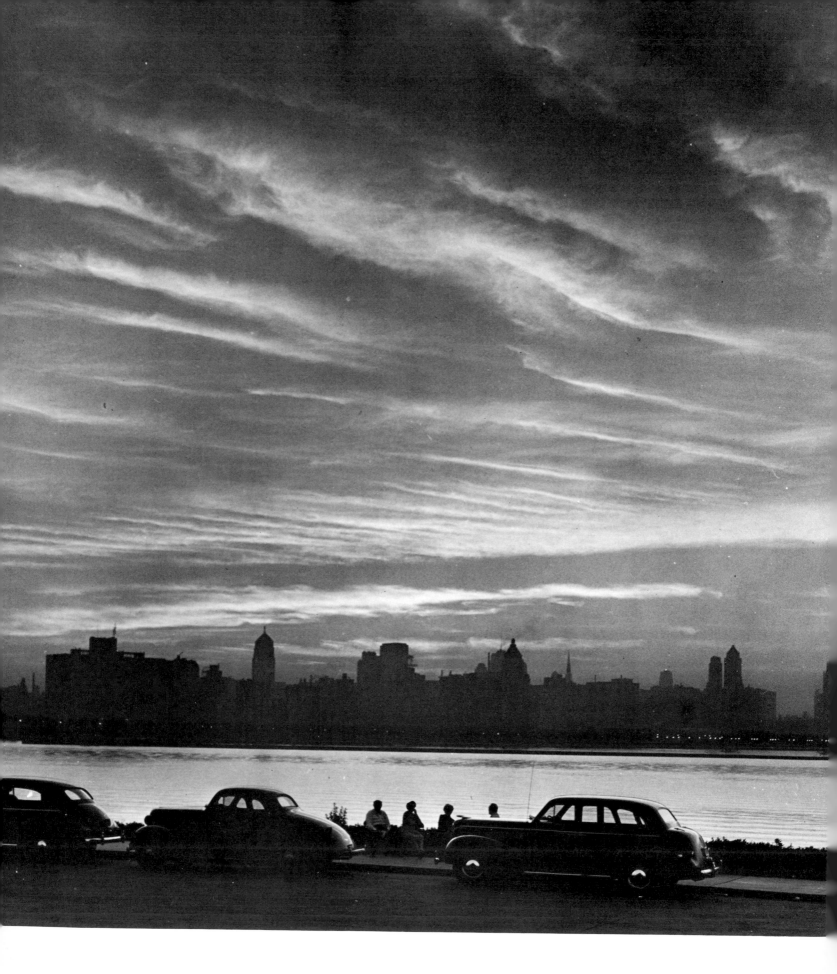

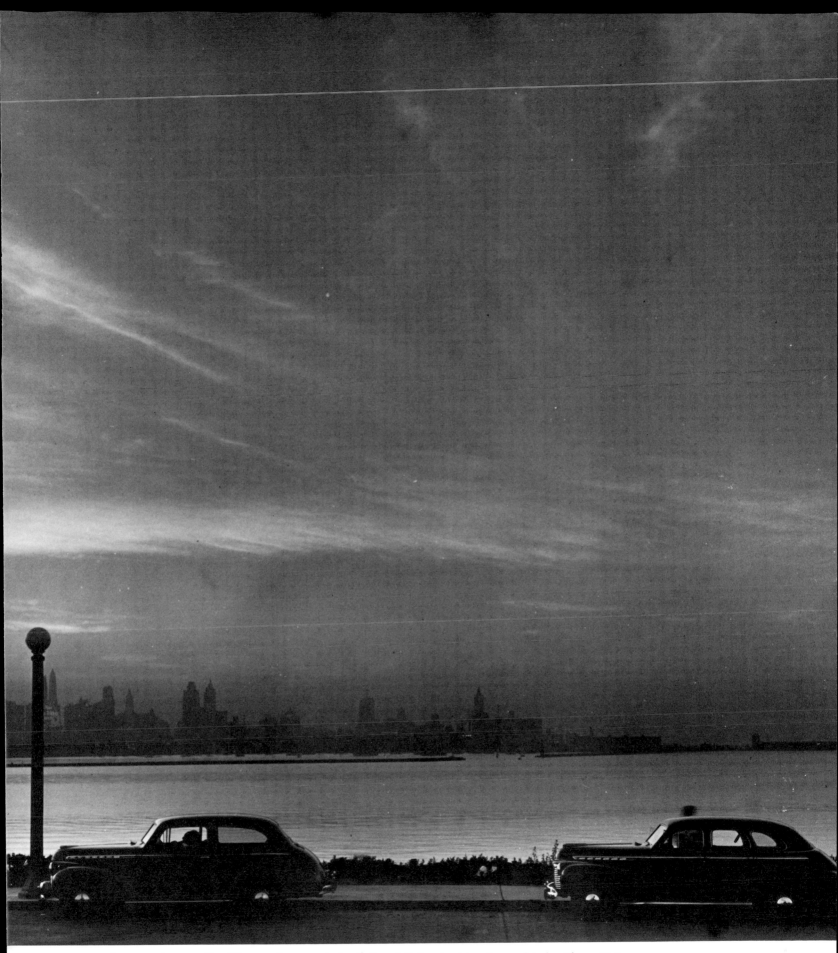

The view from Adler Planetarium on Achsah Bond Drive looking toward Lake Shore Drive.

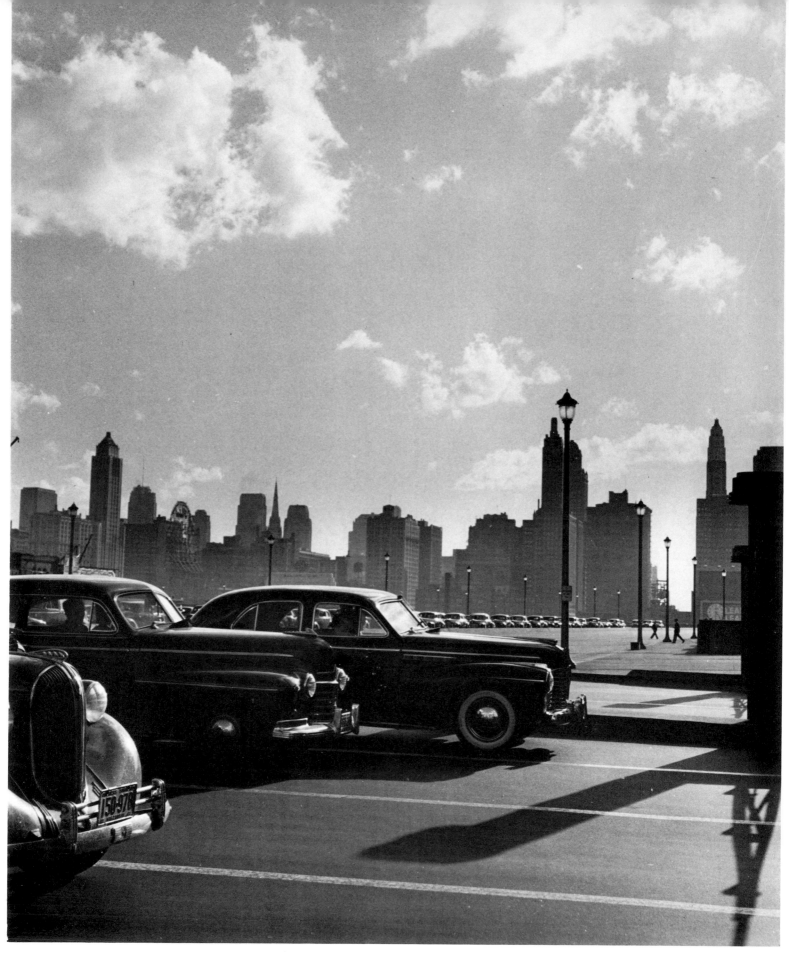

Lake Shore Drive.

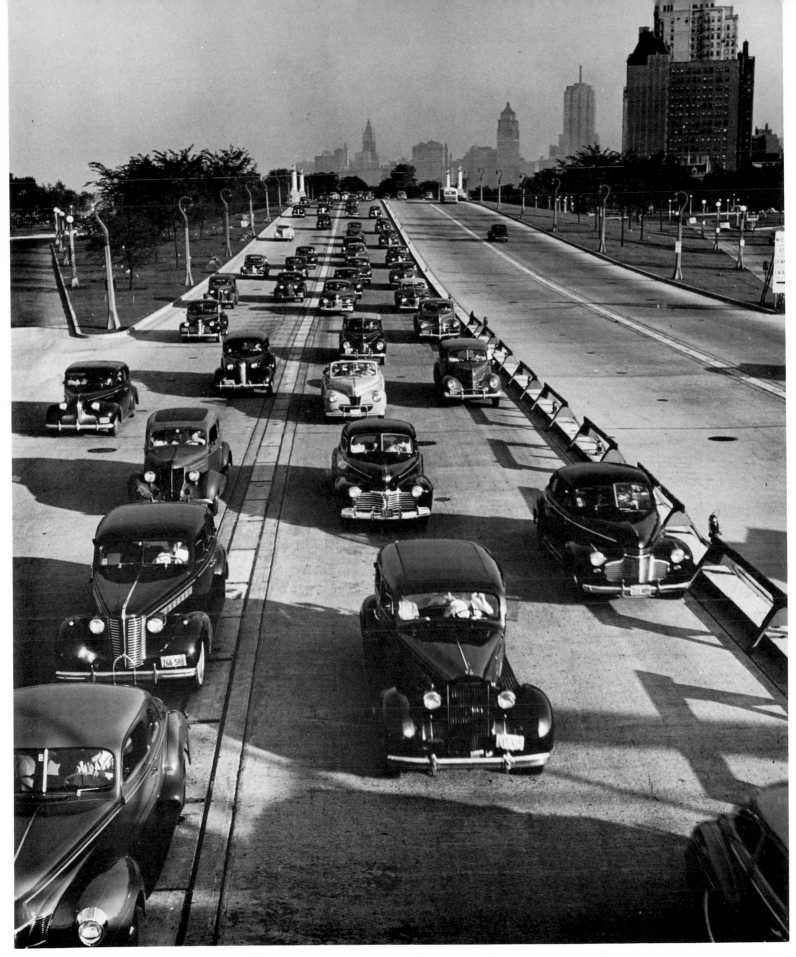

Lake Shore Drive looking south from North Avenue.

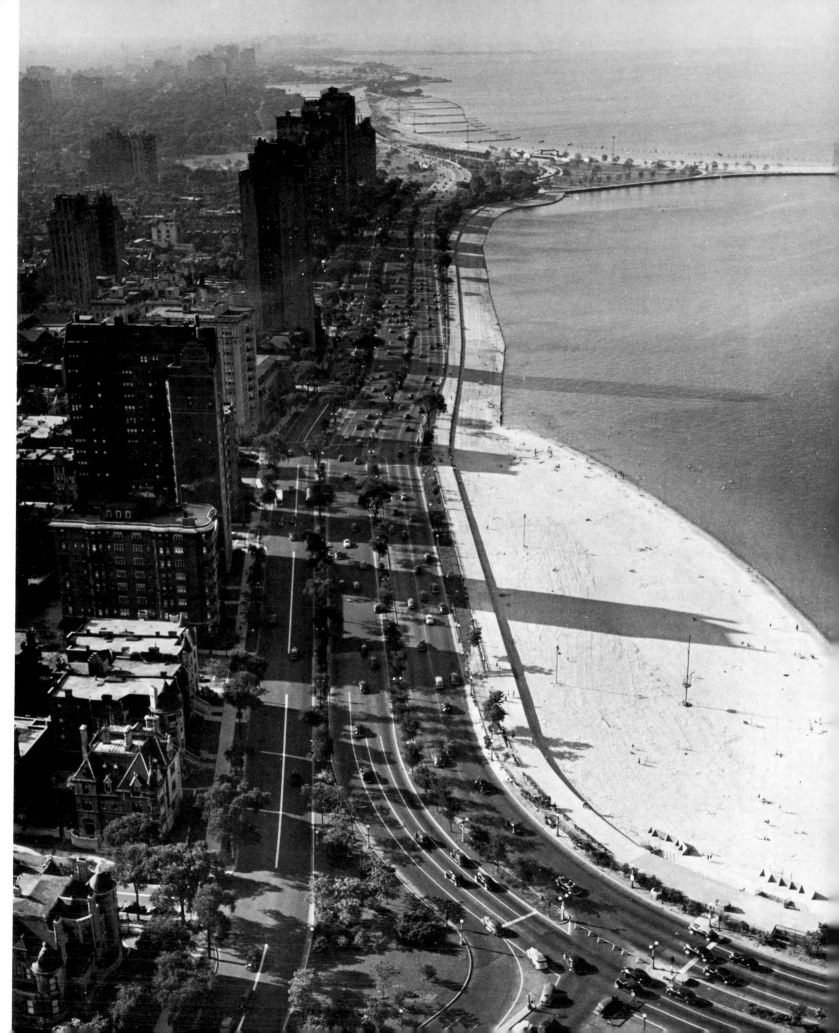

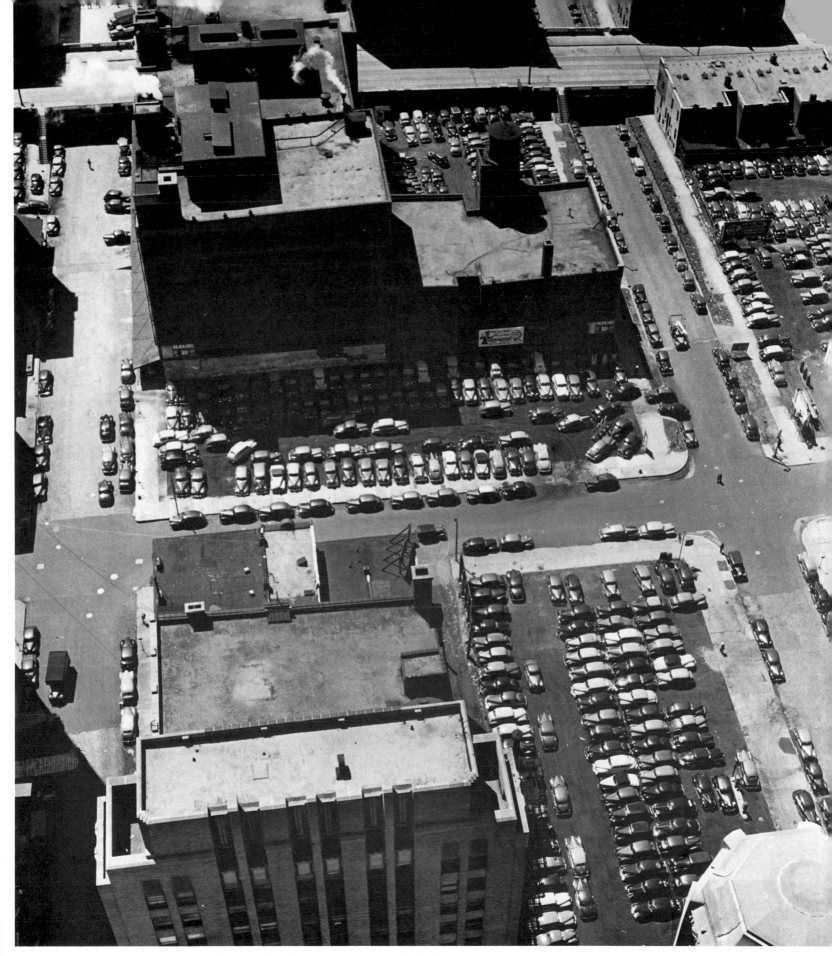

Opposite: A view looking north over Lake Shore Drive.
Above: A view from the Chicago Tribune Building.

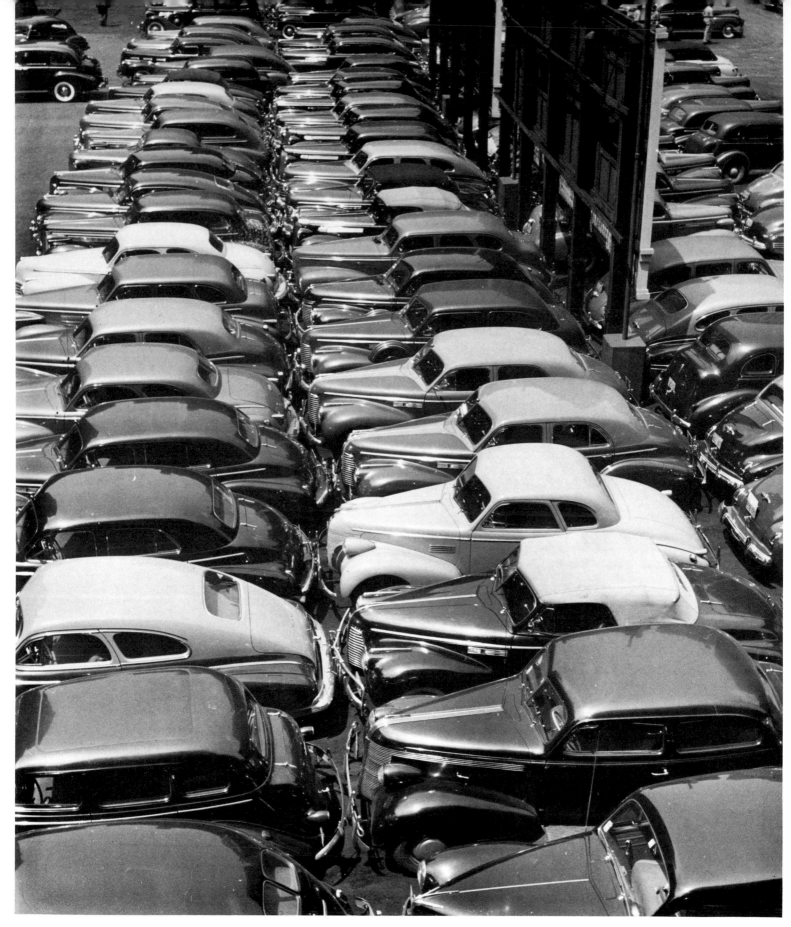

A parking lot.

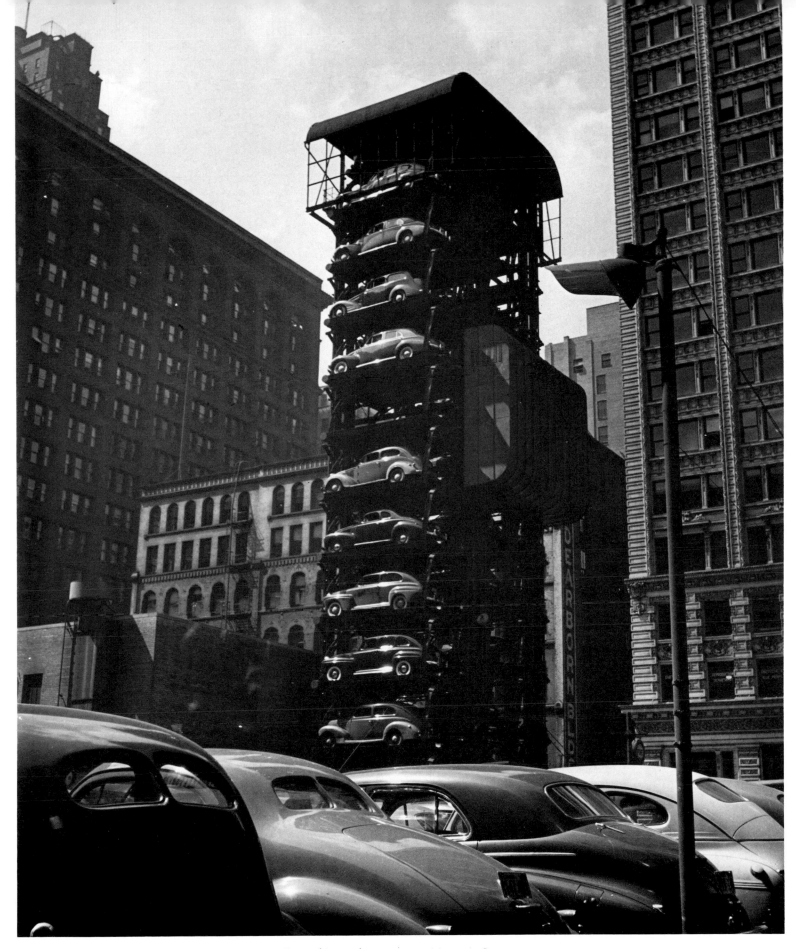

A parking elevator on Monroe Street.

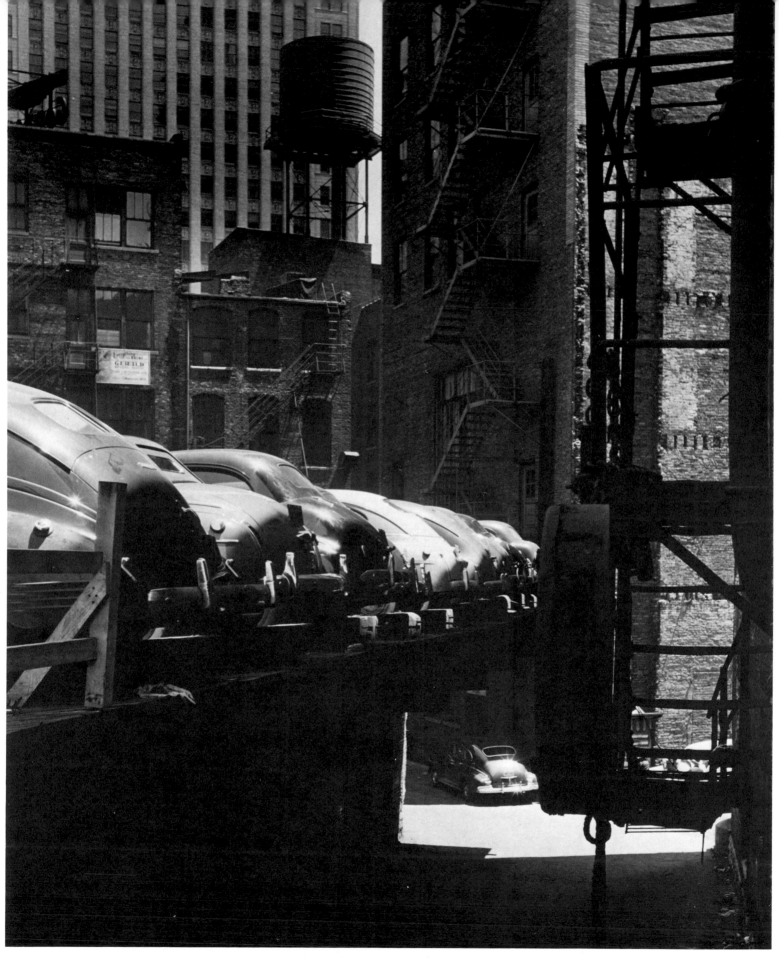

Parking on Wacker Drive.

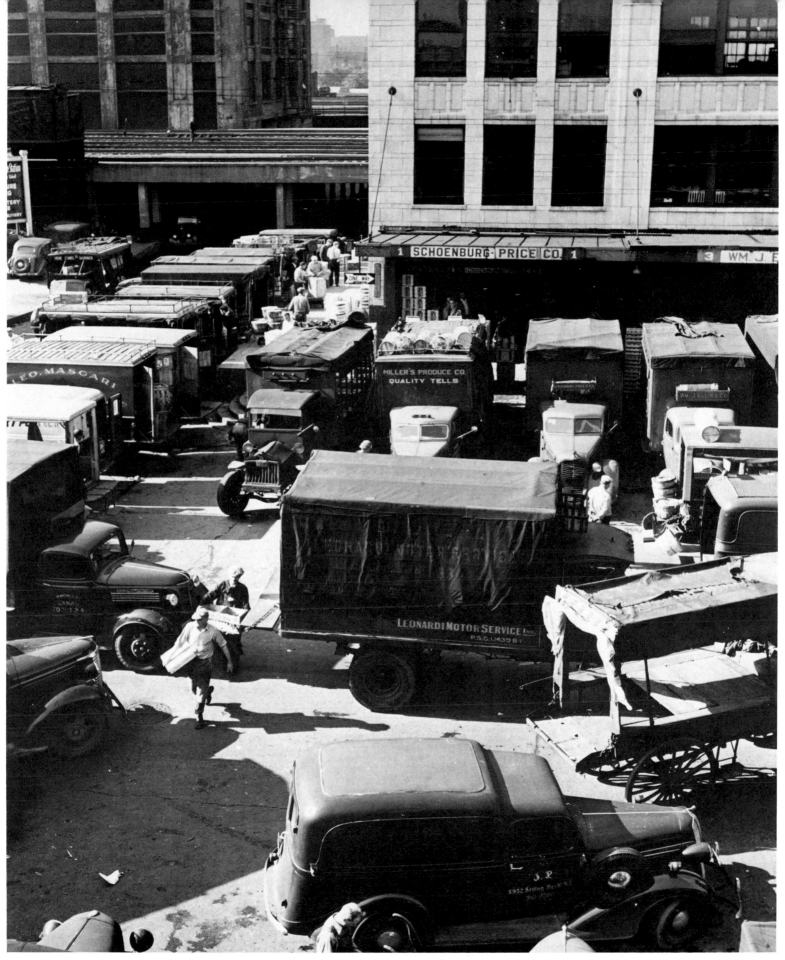

Produce market.

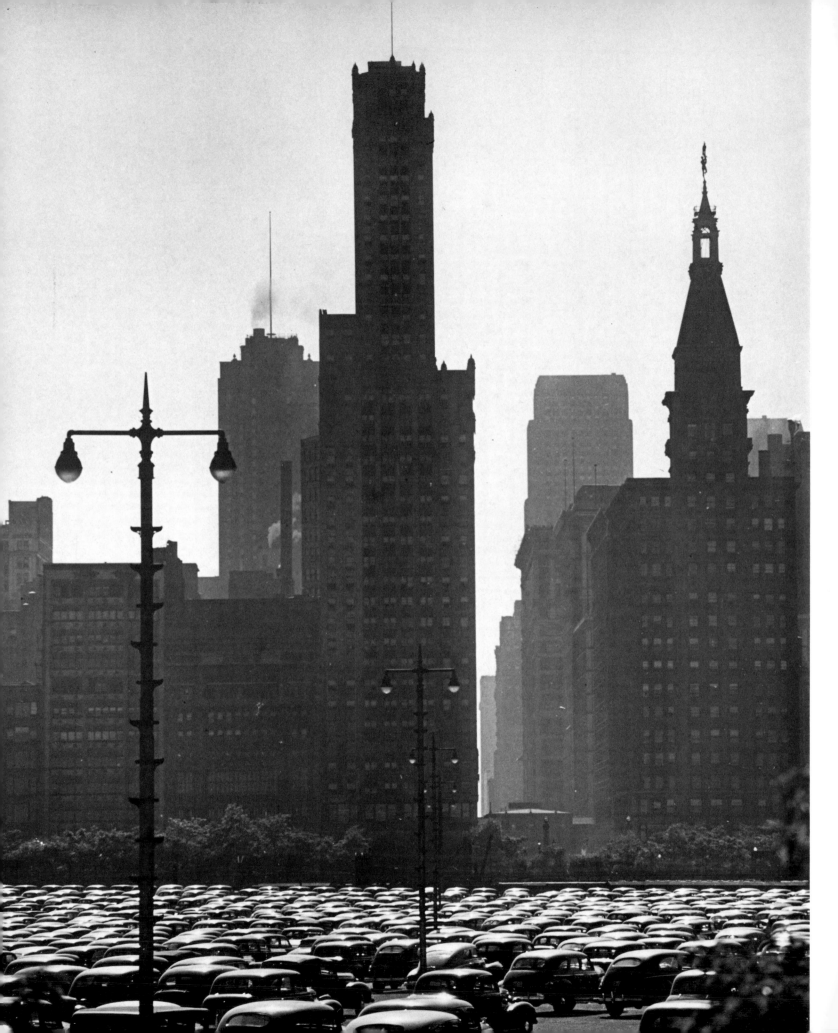

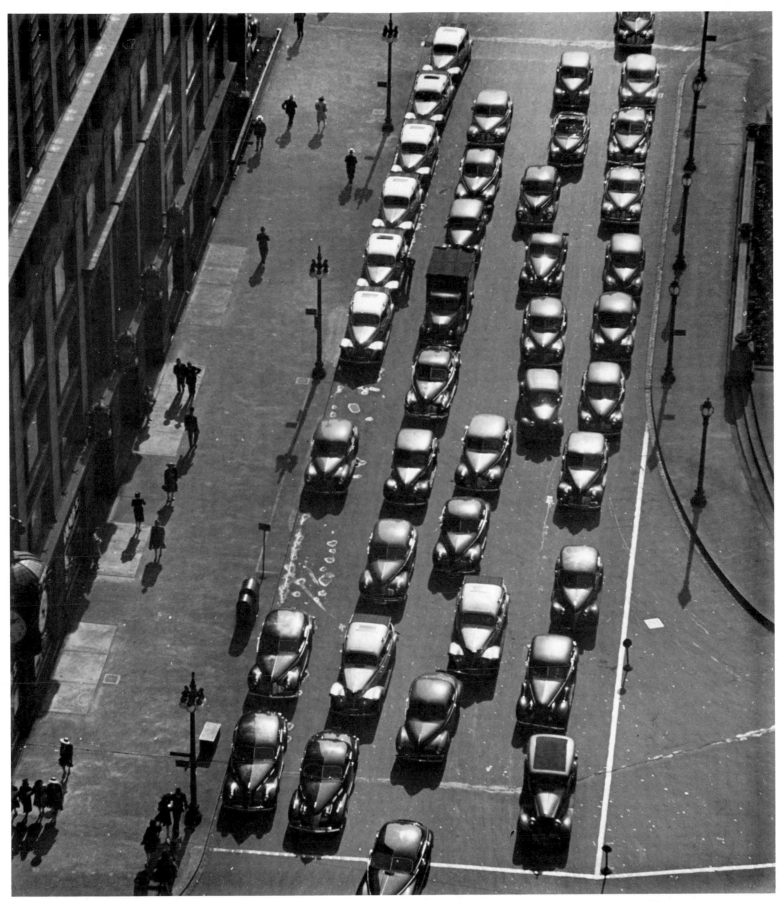

Opposite: A parking lot off Lake Shore Drive. To the right is the old Montgomery Ward Building.
Above: Wacker Drive seen from the Motor Club Building.

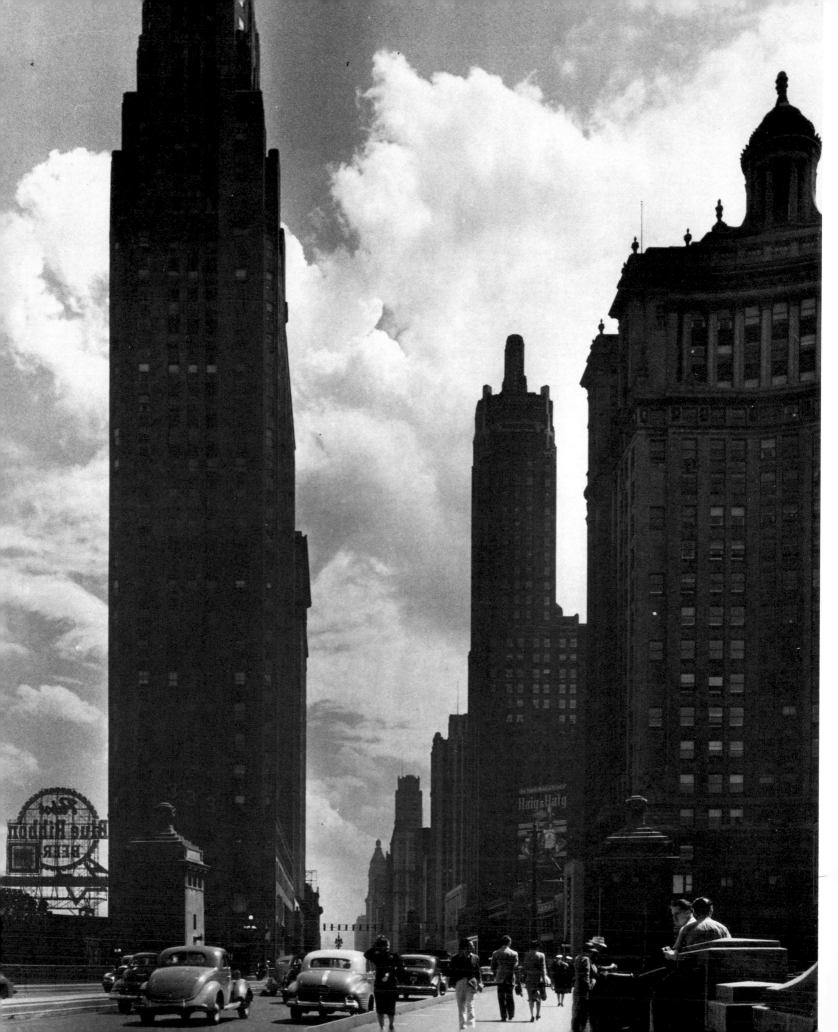

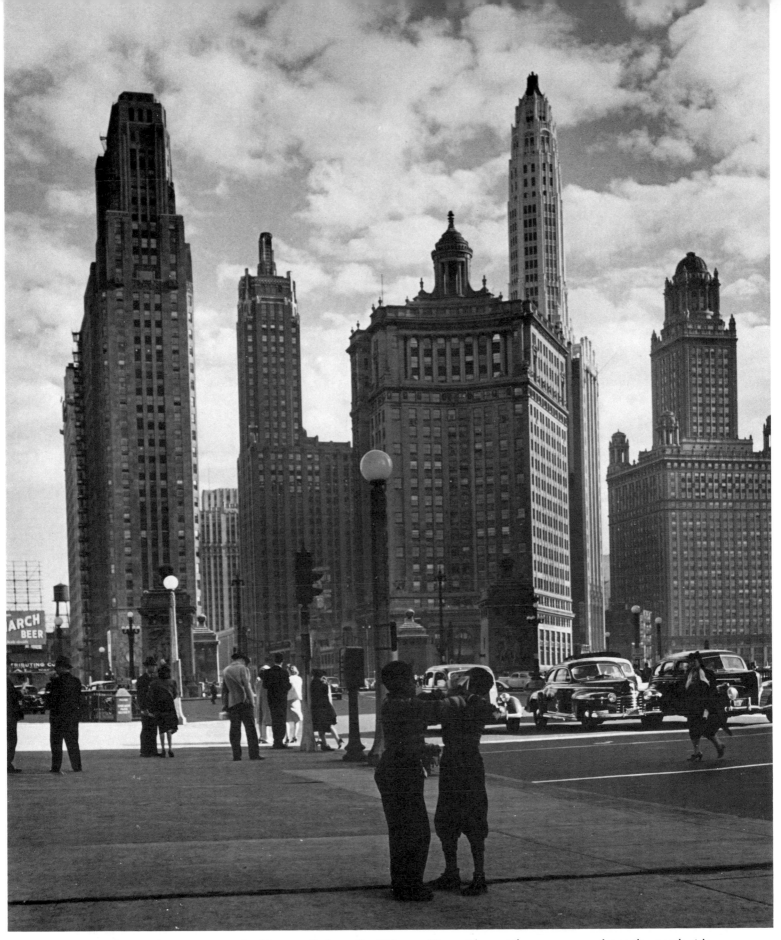

Opposite: Michigan Avenue looking south from the Chicago River. *Above:* The same, seen from the north side of the river. The buildings are (from left to right) 333 North Michigan Avenue Building, Carbon and Carbide Building, London Guarantee and Accident Building, Mather Tower and Pure Oil Building.

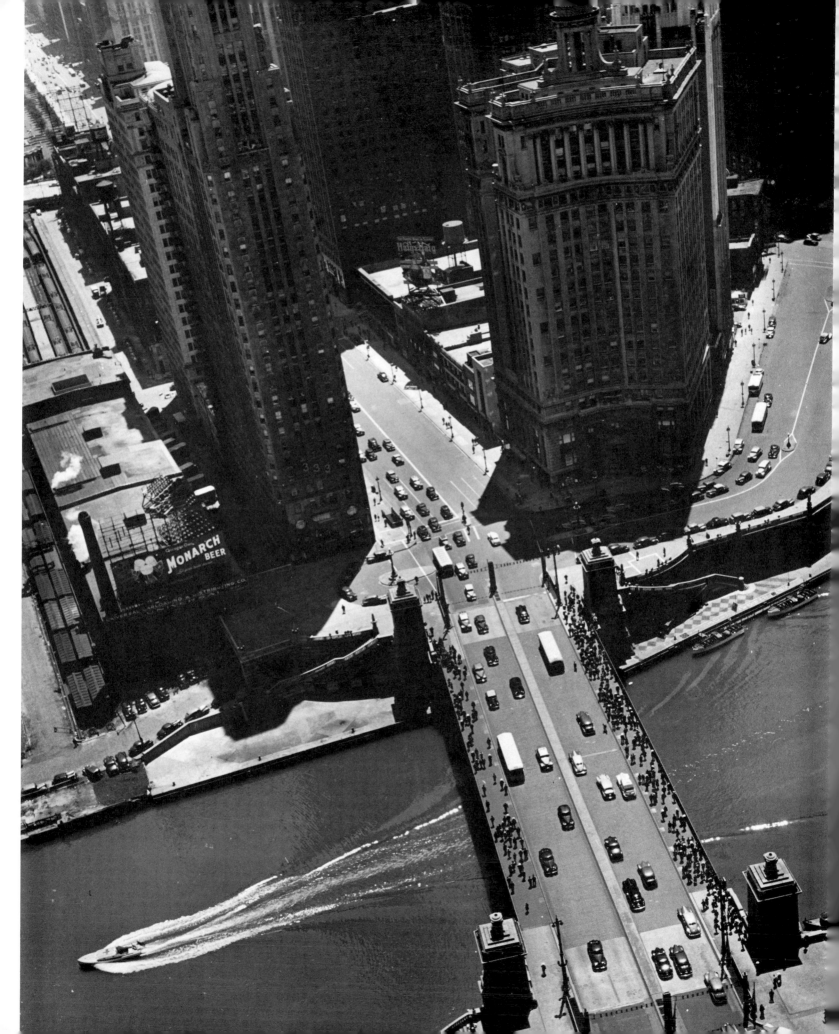

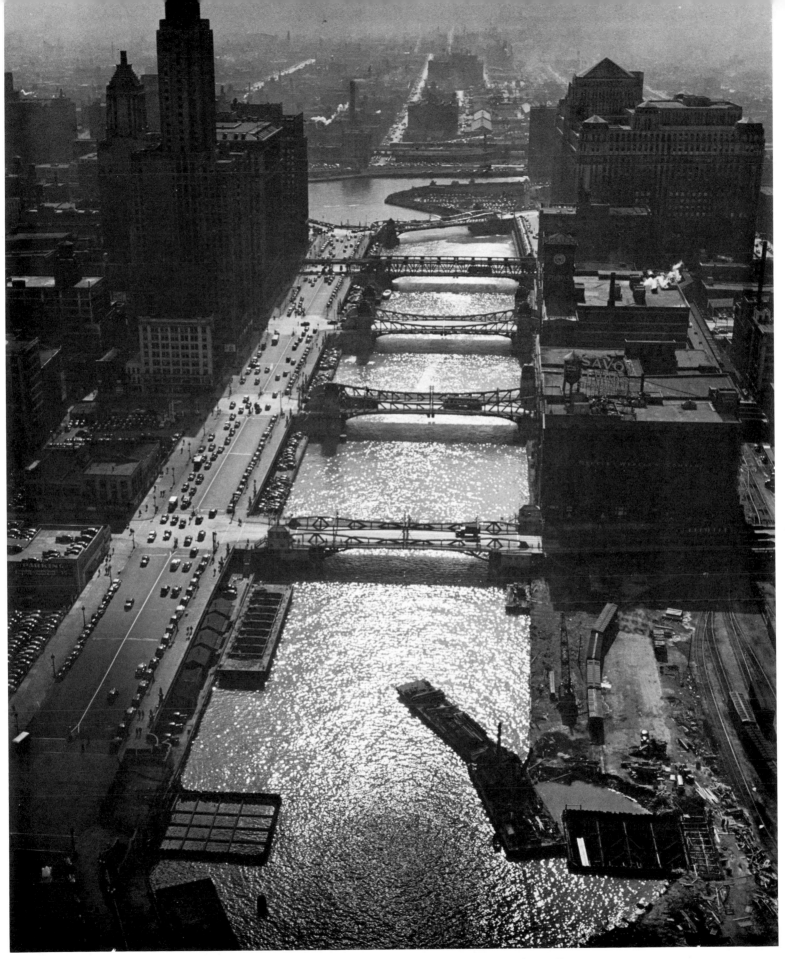

Opposite: The Chicago River seen from the Chicago Tribune Tower.
Above: The Chicago River seen from the Mather Tower.

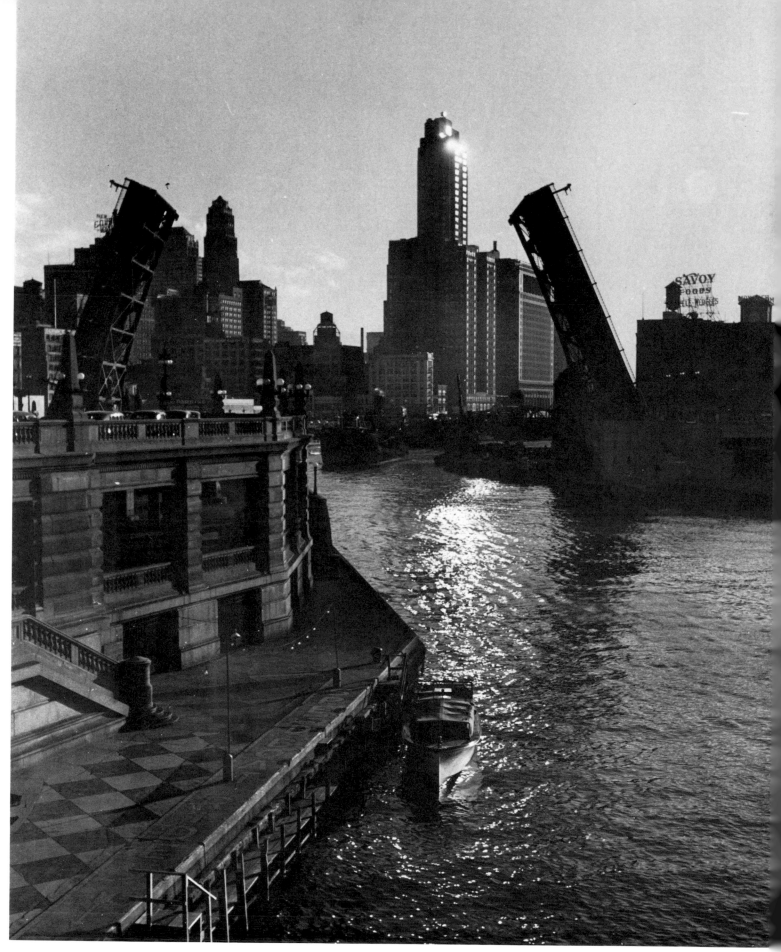

The Chicago River looking west.

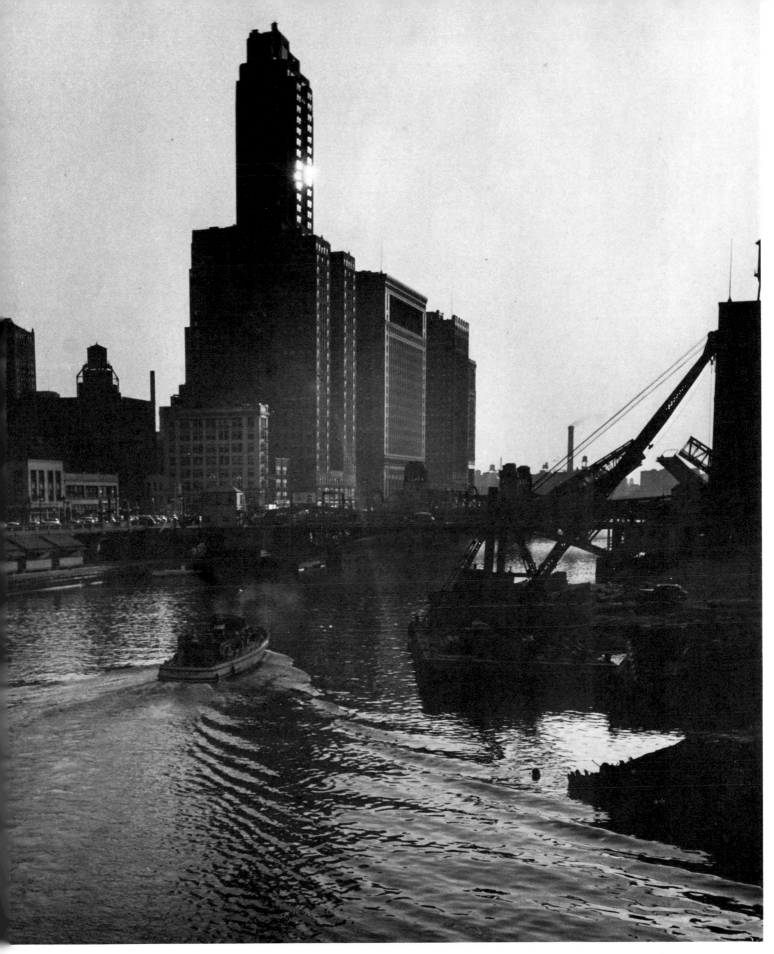

The Chicago River looking west.

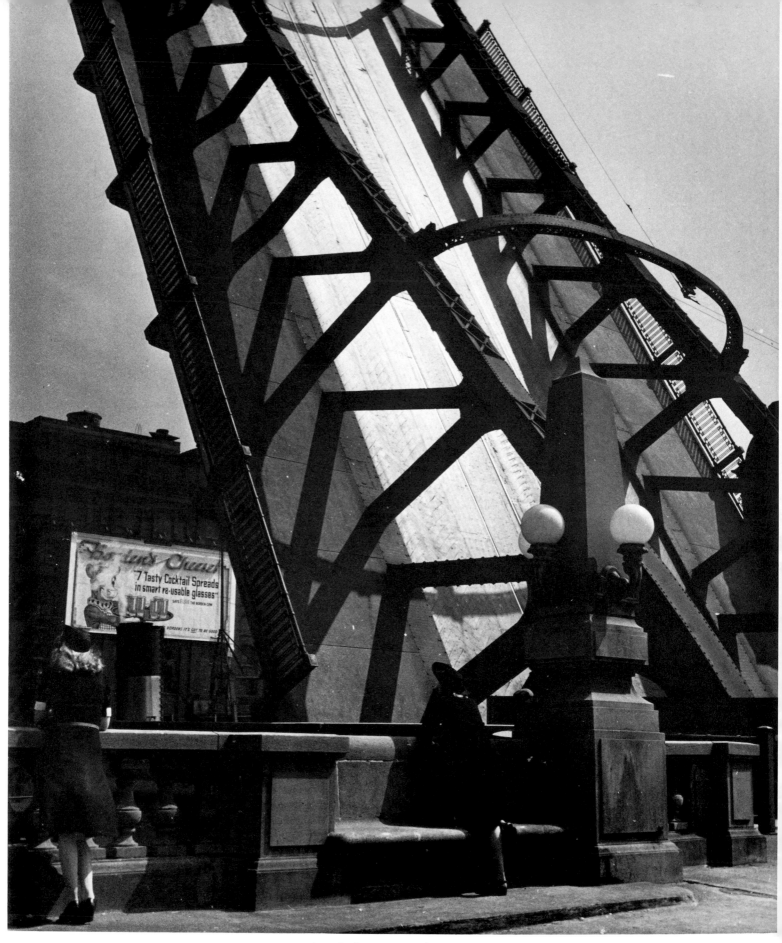

The Clark Street Bridge.

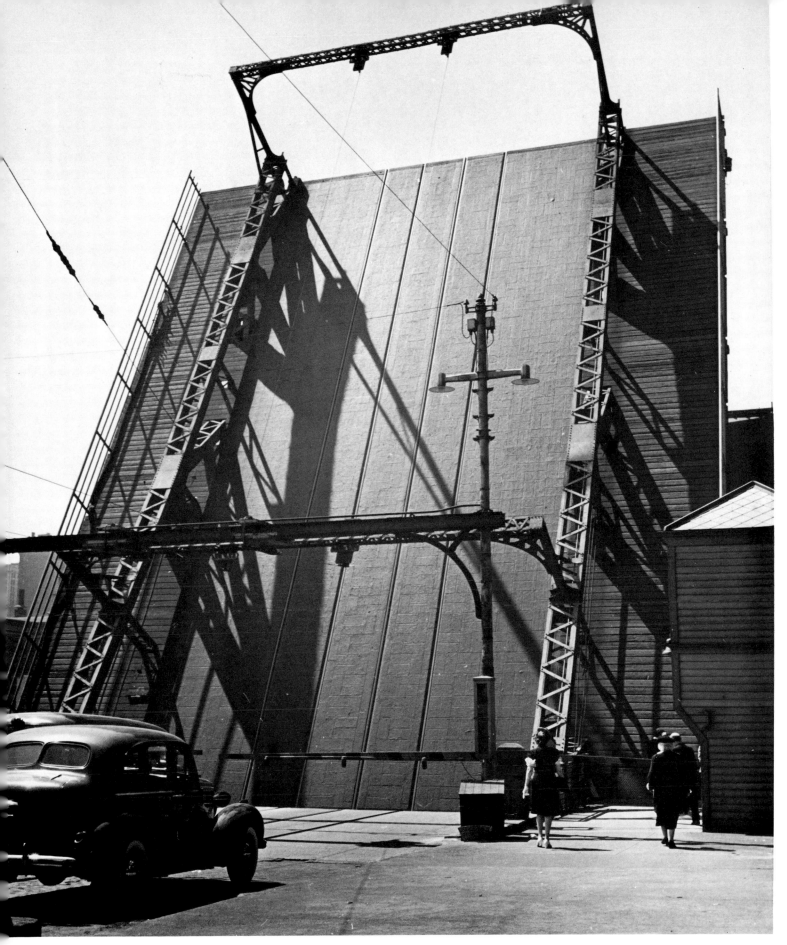

A bridge over the Chicago River.

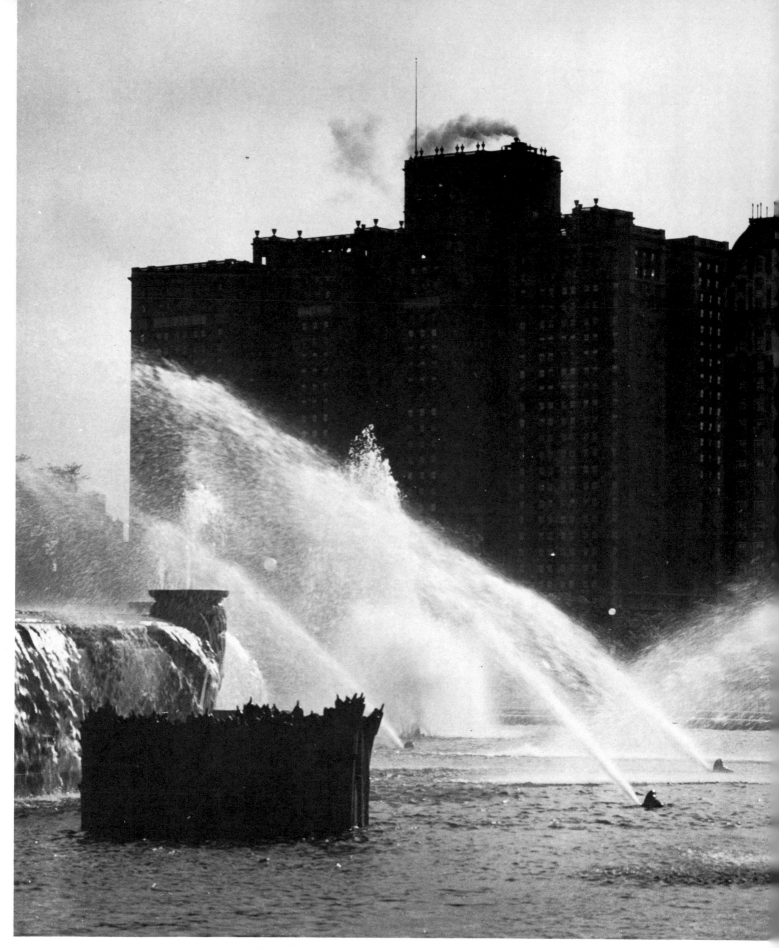

Buckingham Fountain and the Stevens Hotel.

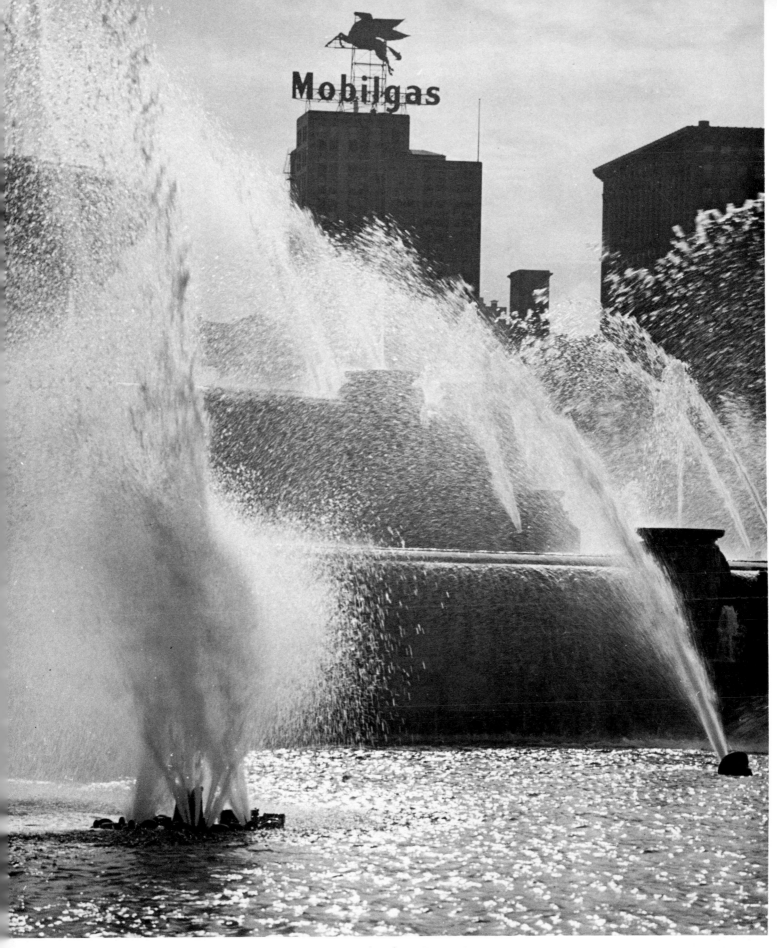

Buckingham Fountain.

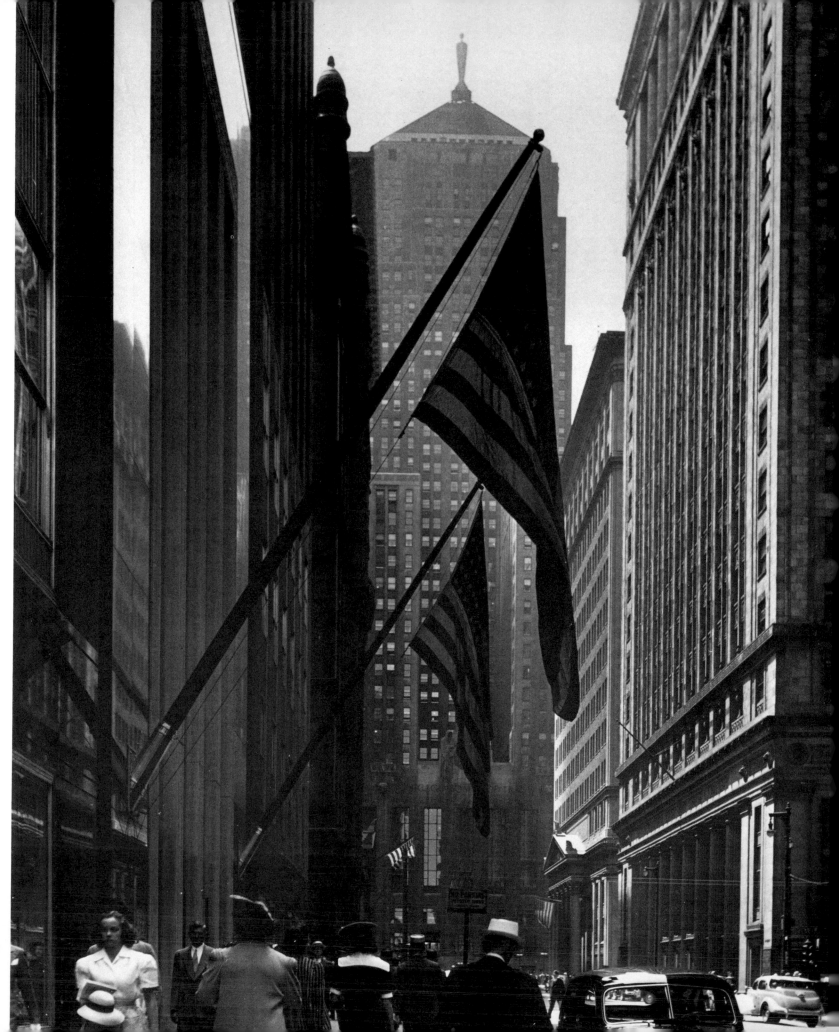

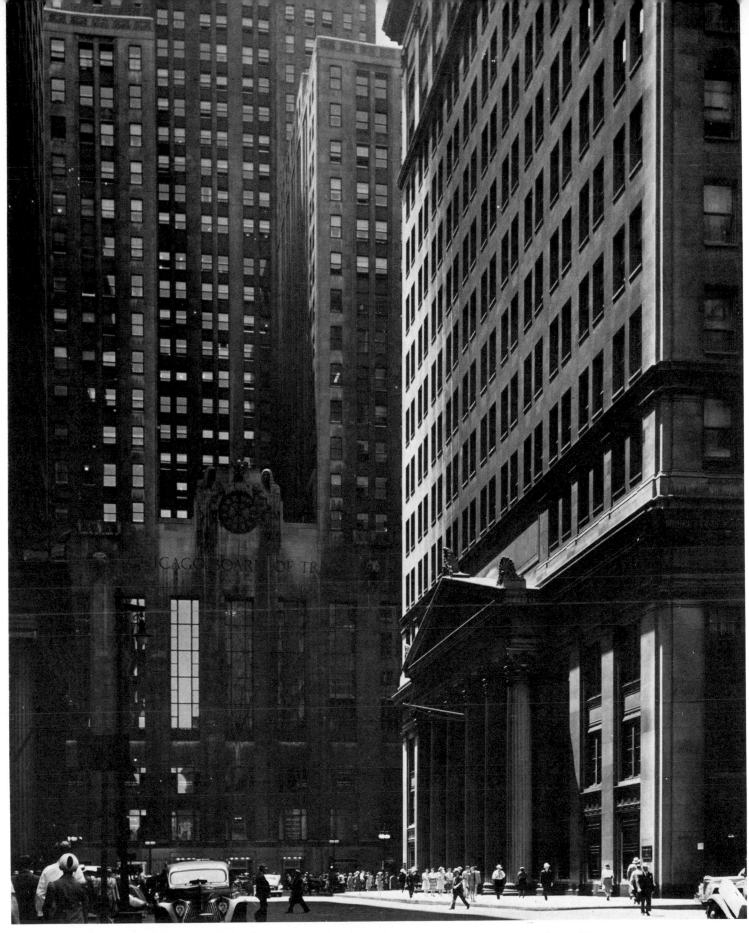

Opposite and above: La Salle Street with the Chicago Board of Trade Building.

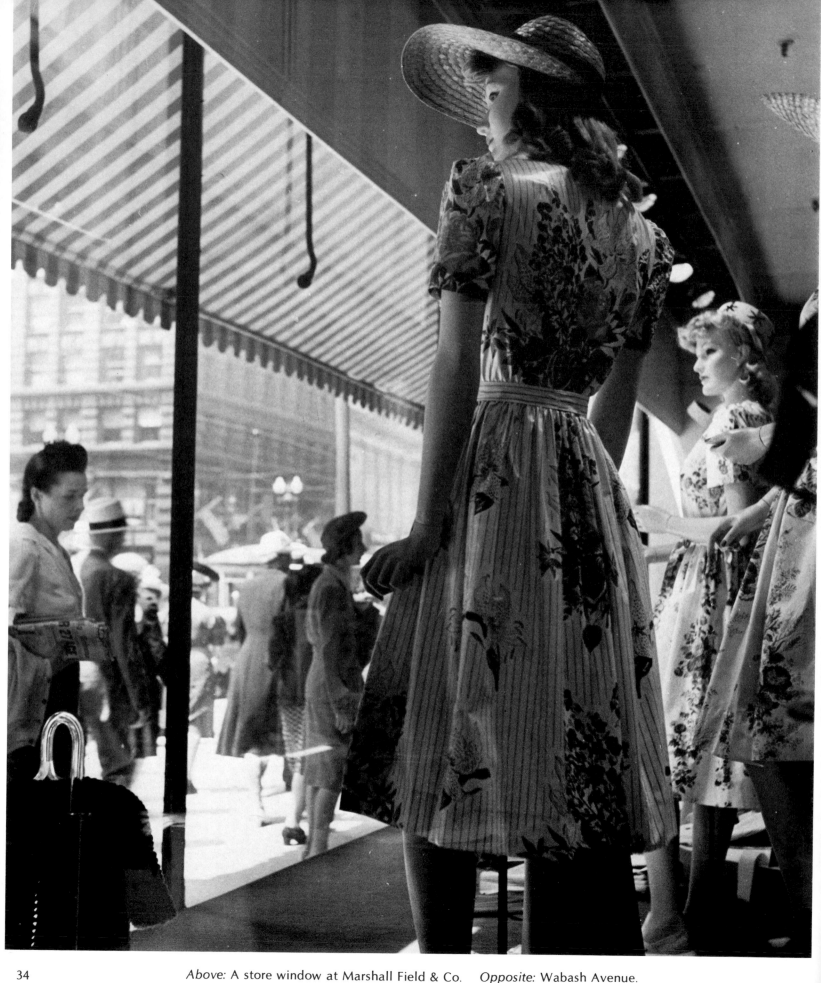

34 *Above:* A store window at Marshall Field & Co. *Opposite:* Wabash Avenue.

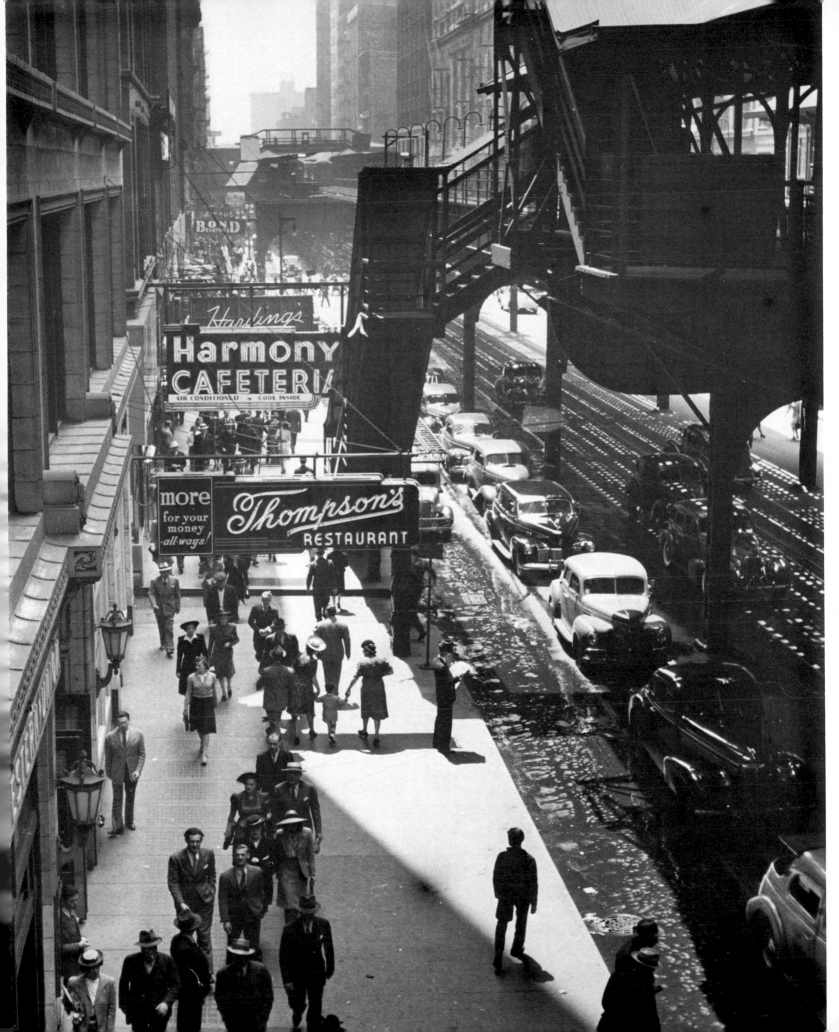

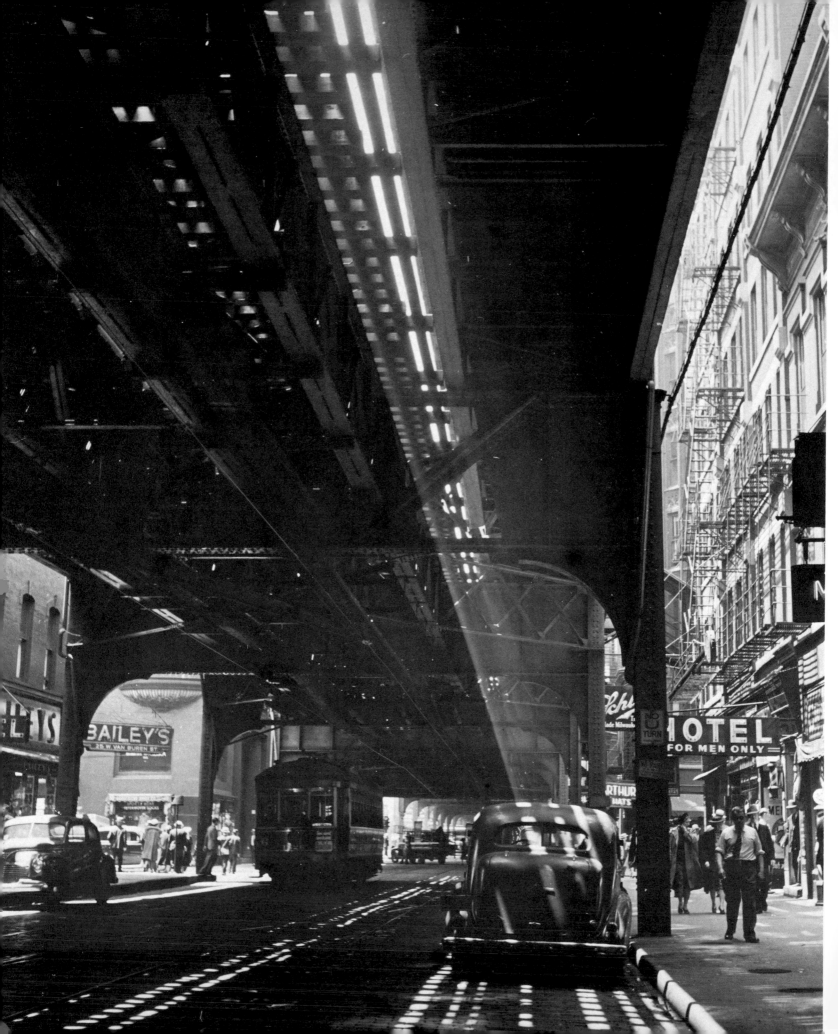

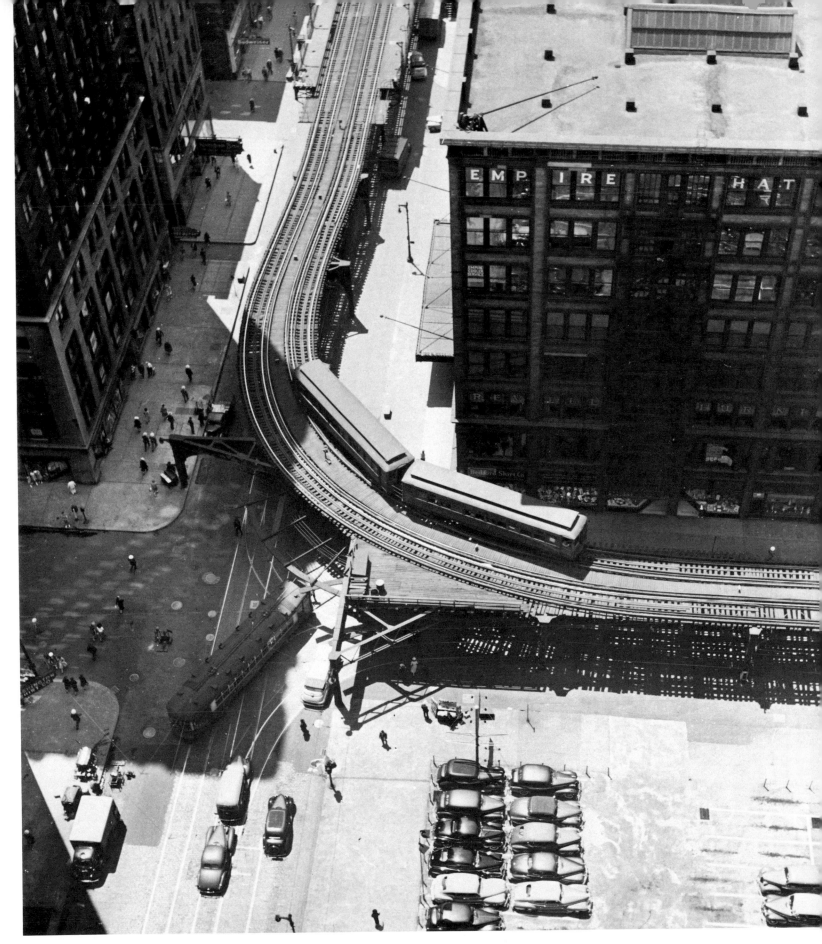

Opposite: Van Buren Street.
Above: Corner of Wabash Avenue and Lake Street.

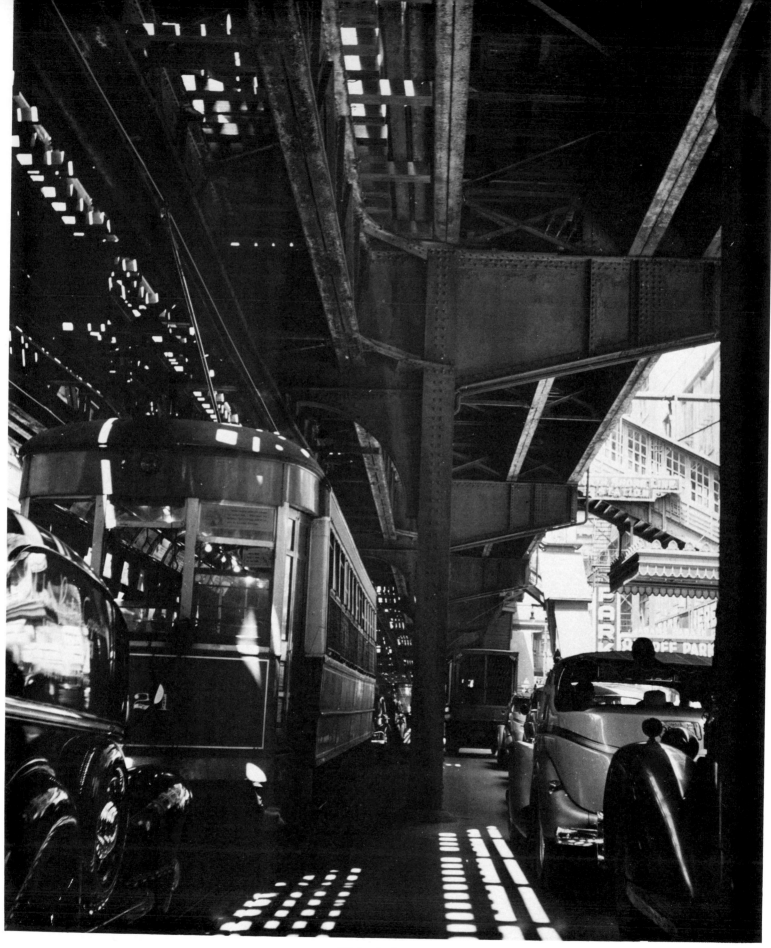

Wabash Avenue.

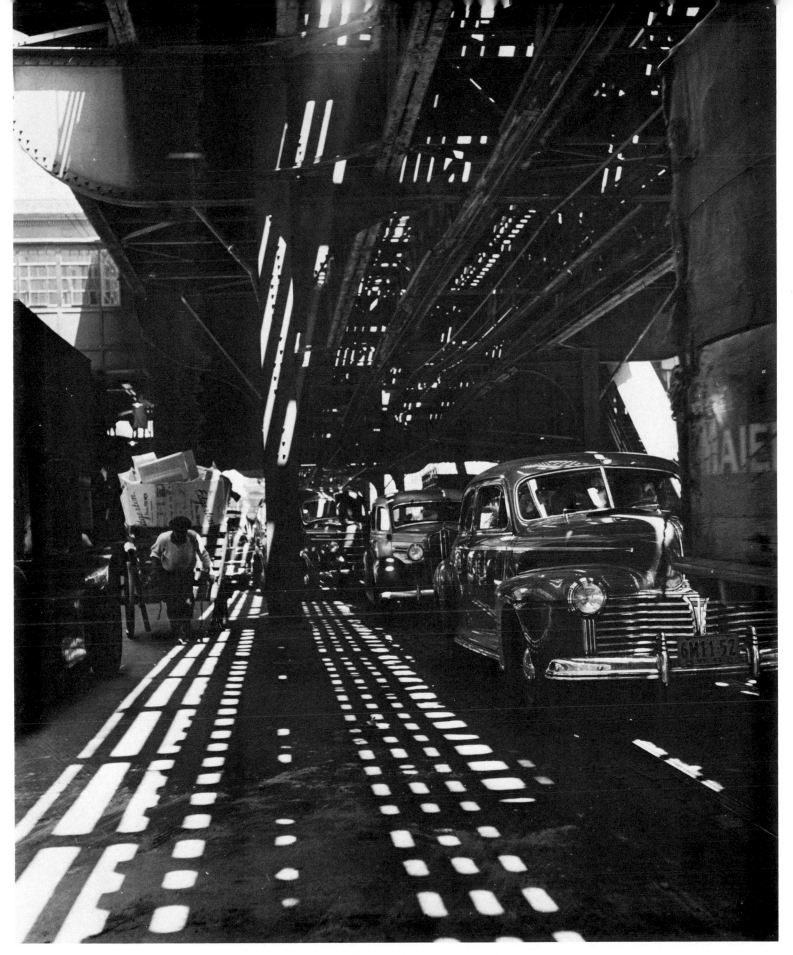

Wabash Avenue.

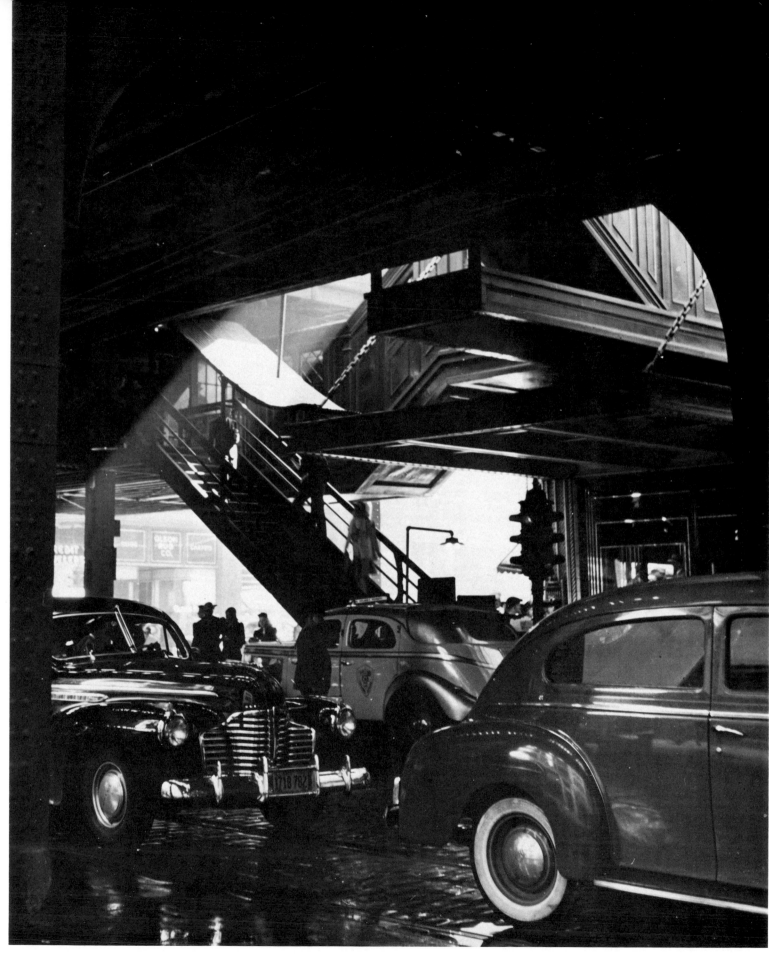

Wabash Avenue.

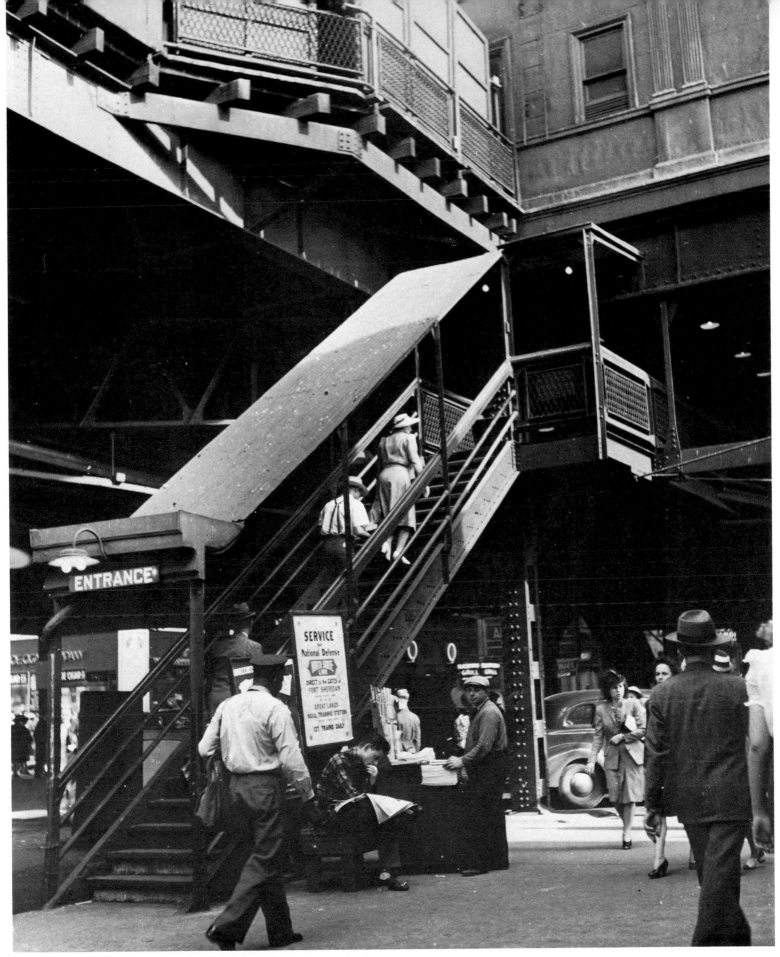

Wabash Avenue.

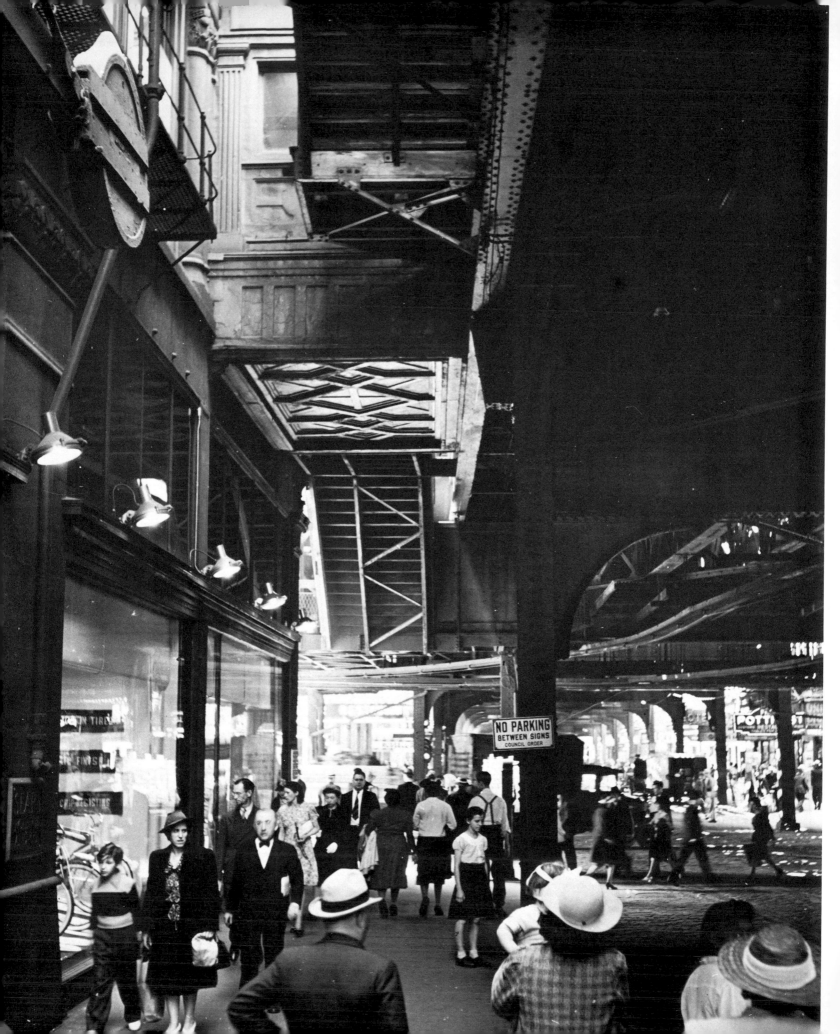

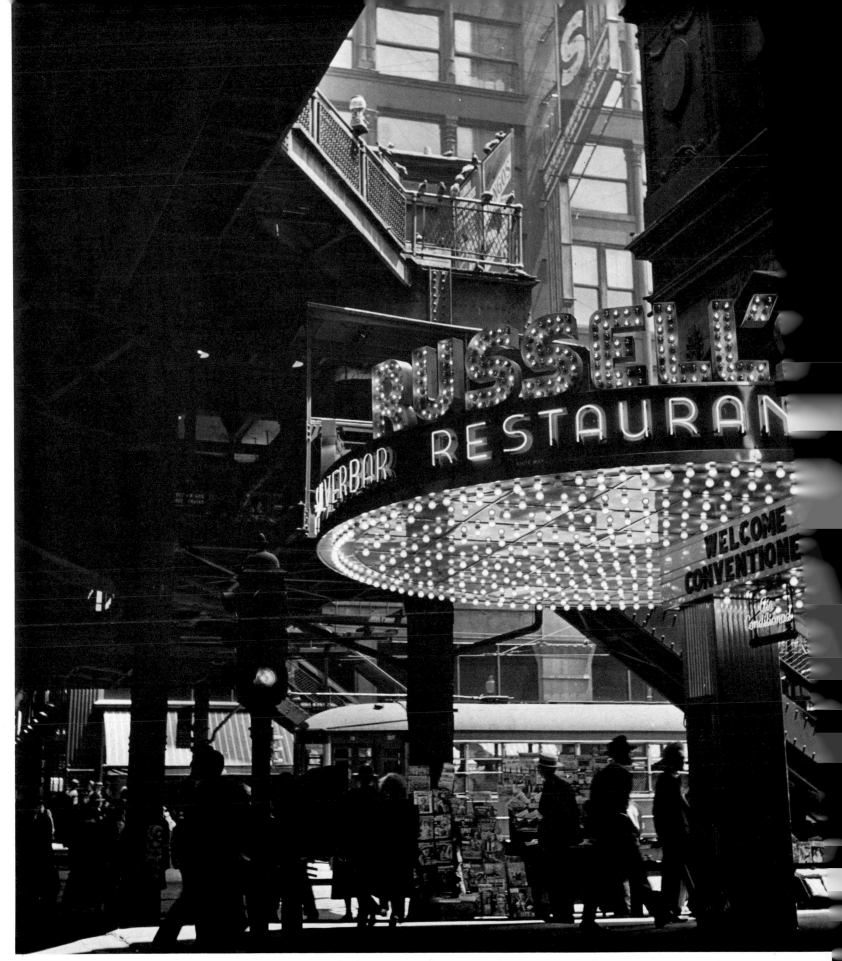

Opposite: Corner of State and Van Buren Streets.
Above: Under the elevated.

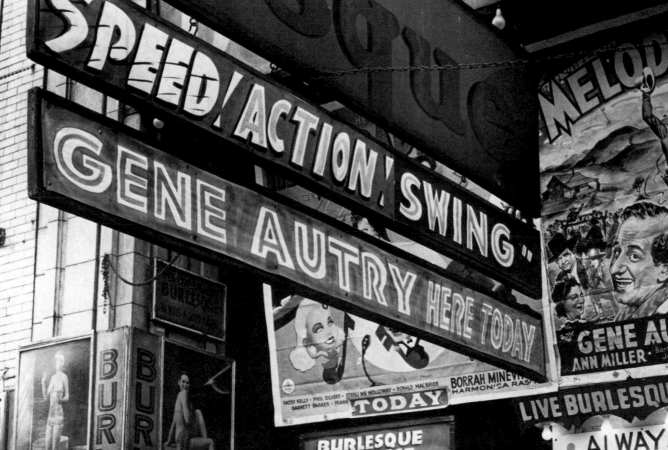
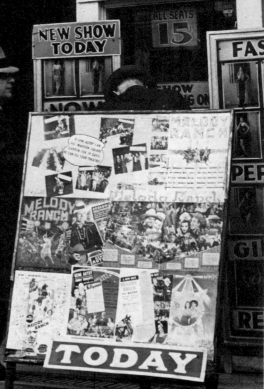
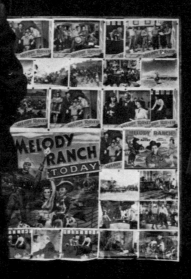

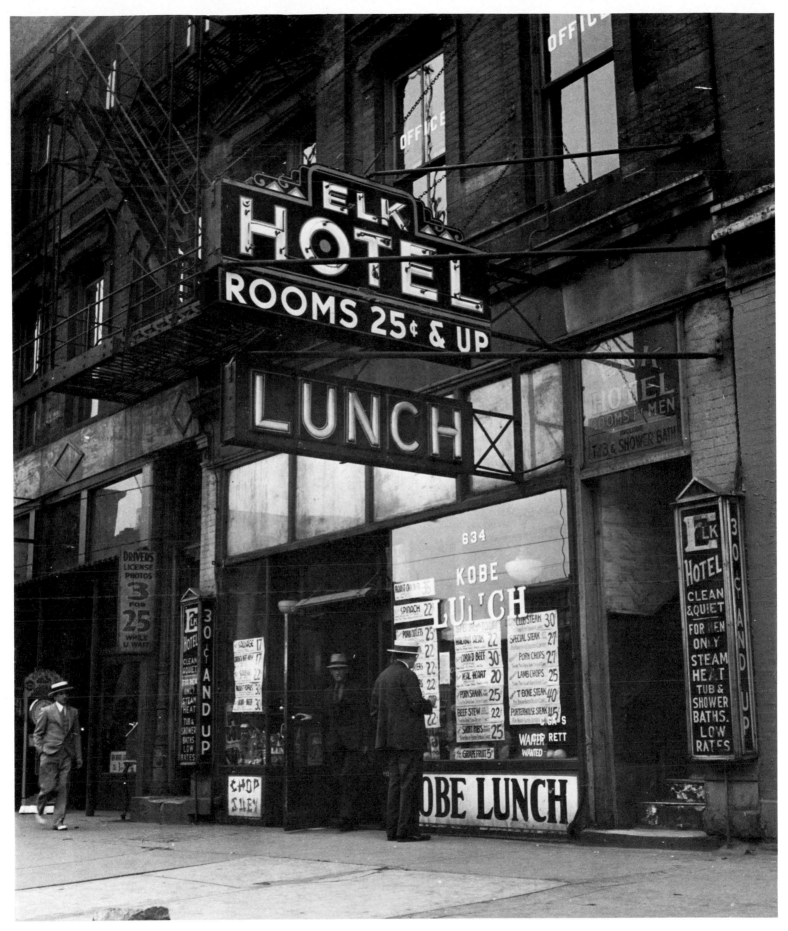

Opposite and above: State Street.

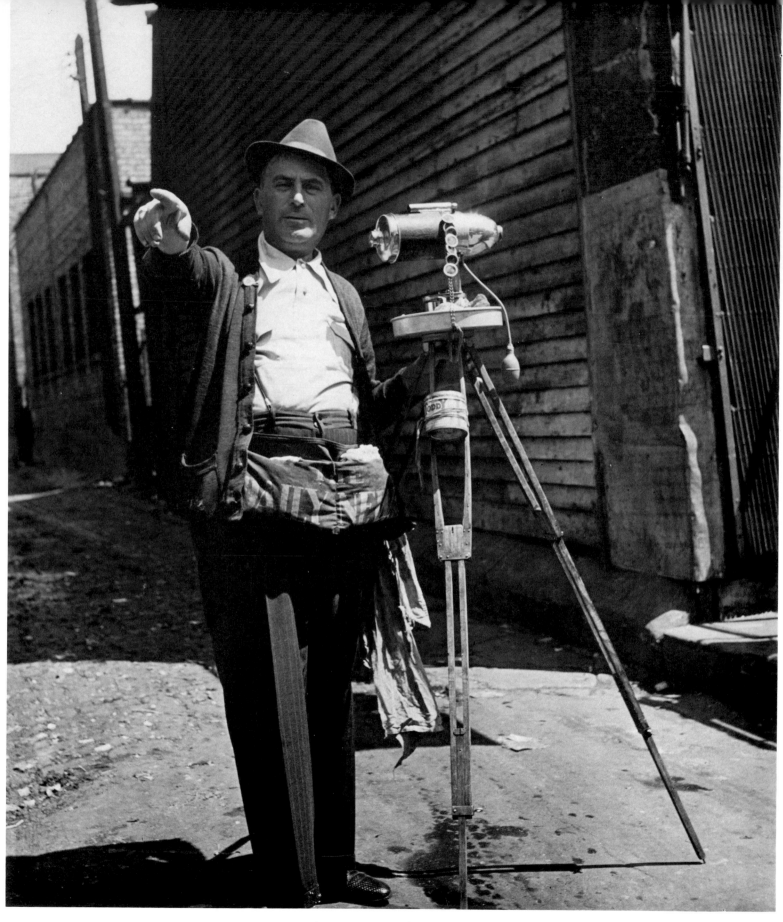

Above: Tintype photographer.
Opposite: Corner of Wabash Avenue and Balbo Drive.

46

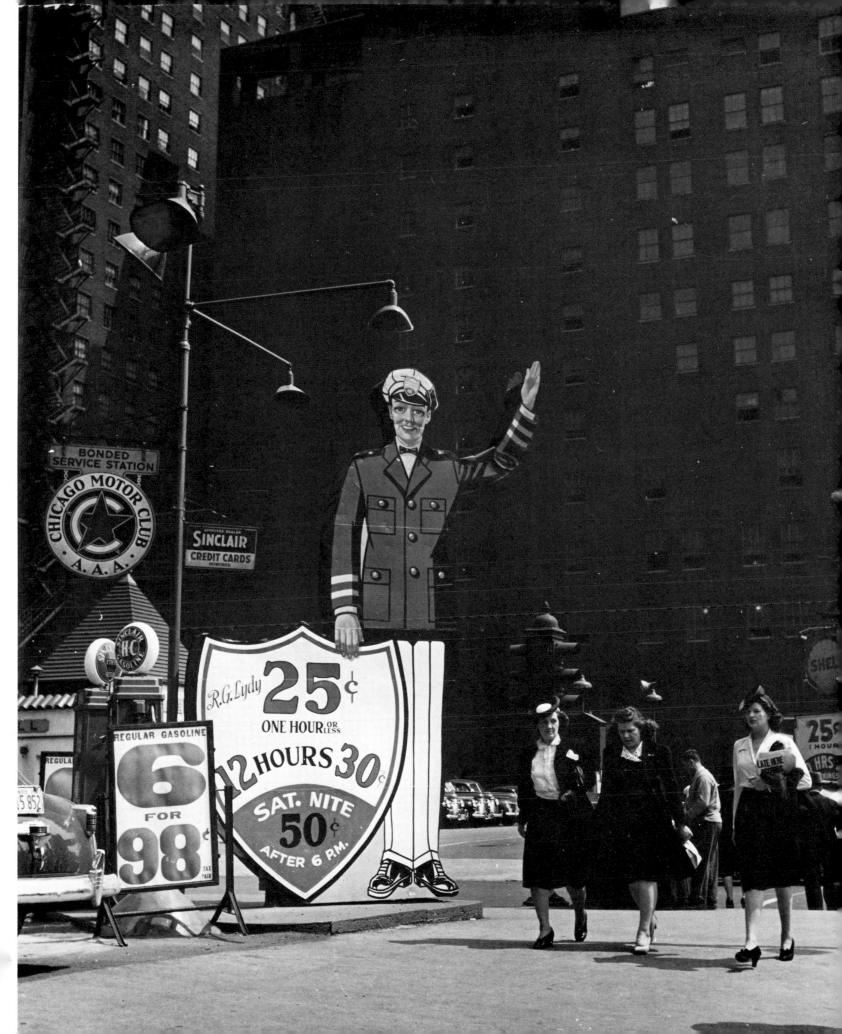

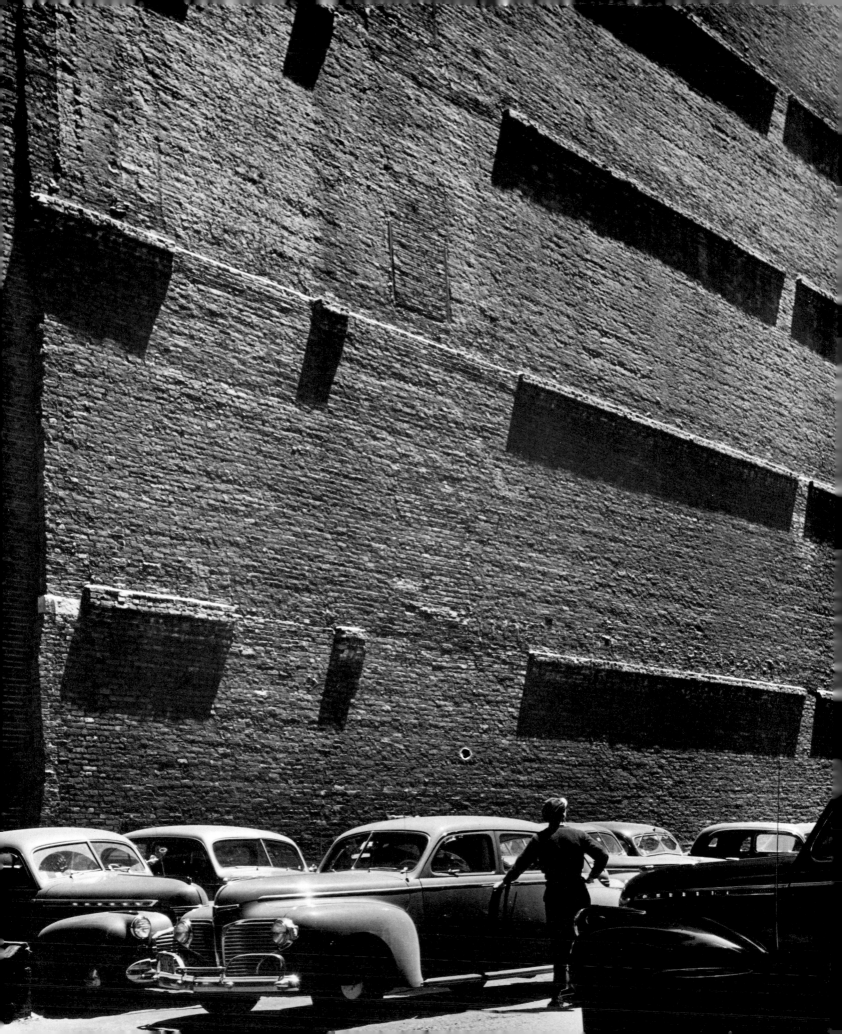

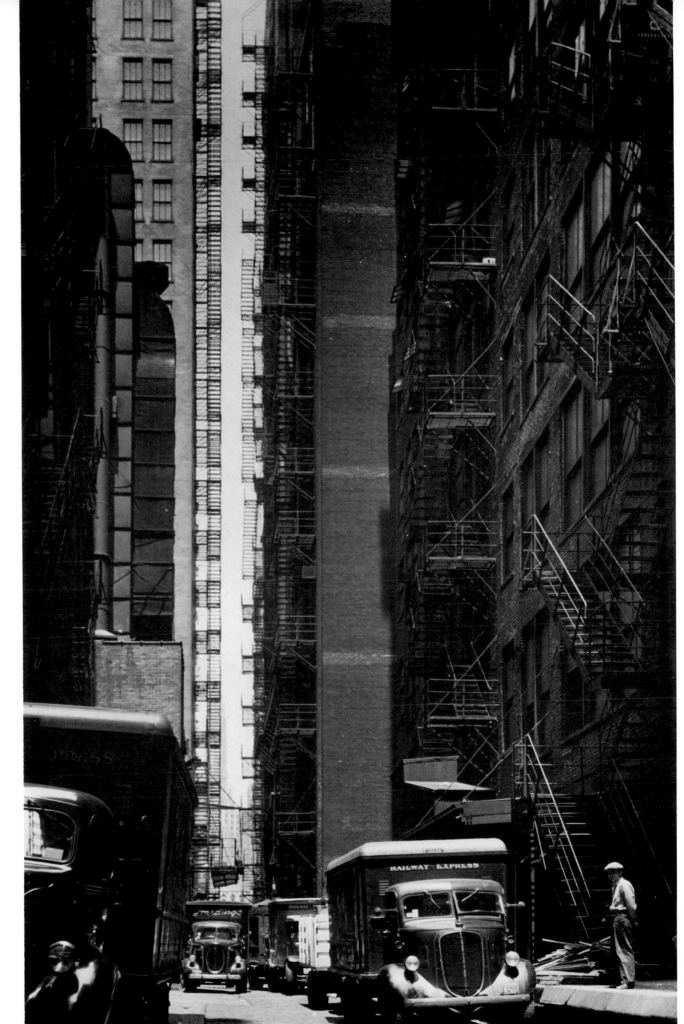

Opposite: Parking near Wabash Avenue and Lake Street.

Right: A truck alley between Michigan and Wabash Avenues.

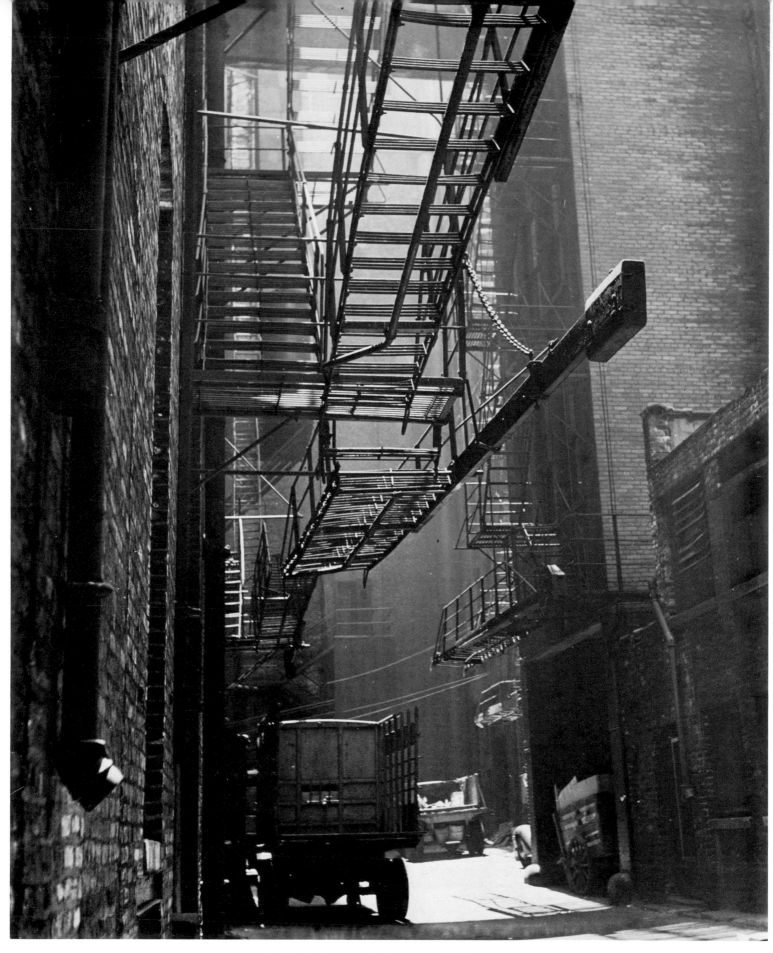

A truck alley between Michigan and Wabash Avenues.

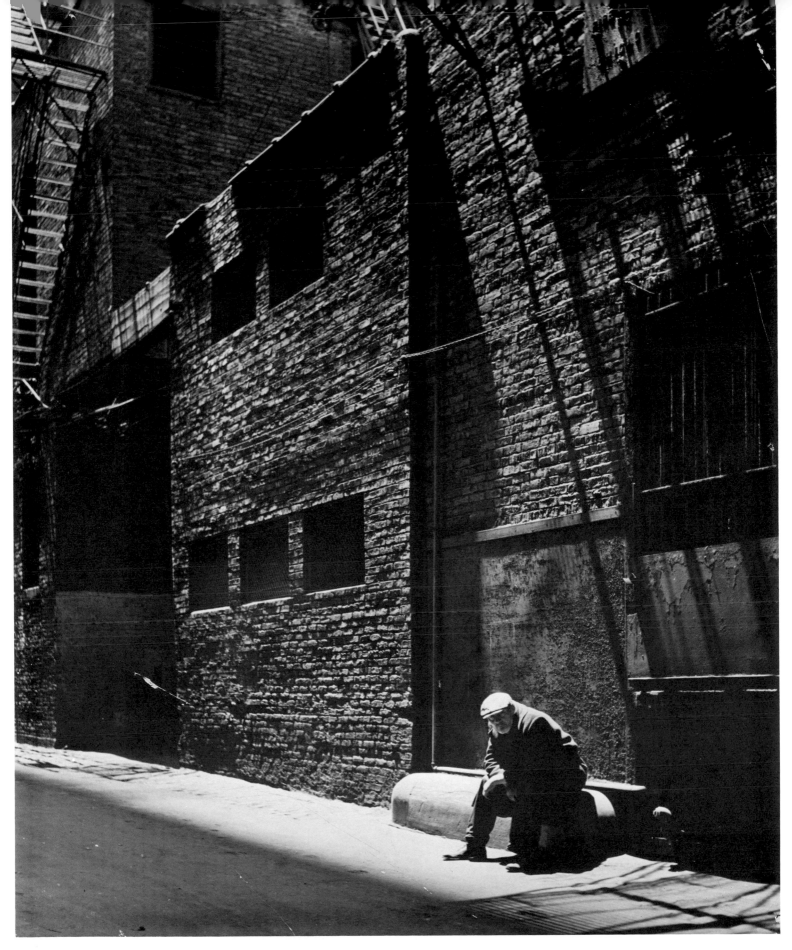

A truck alley between Michigan and Wabash Avenues.

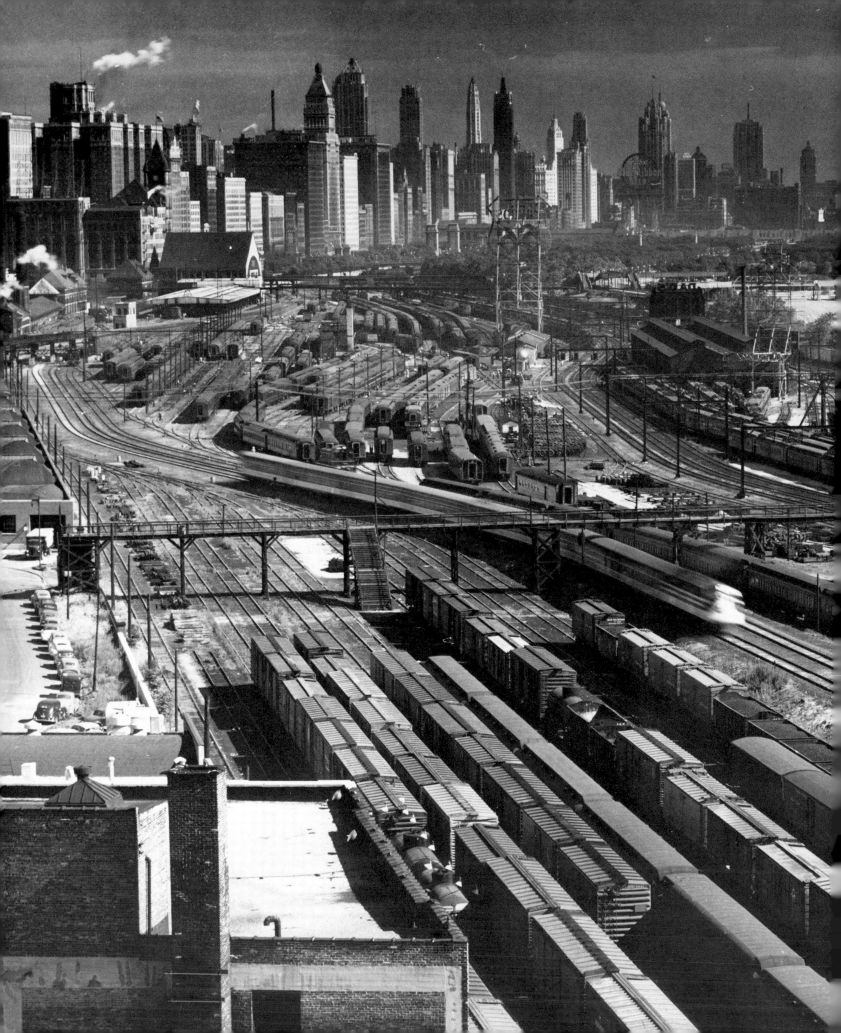

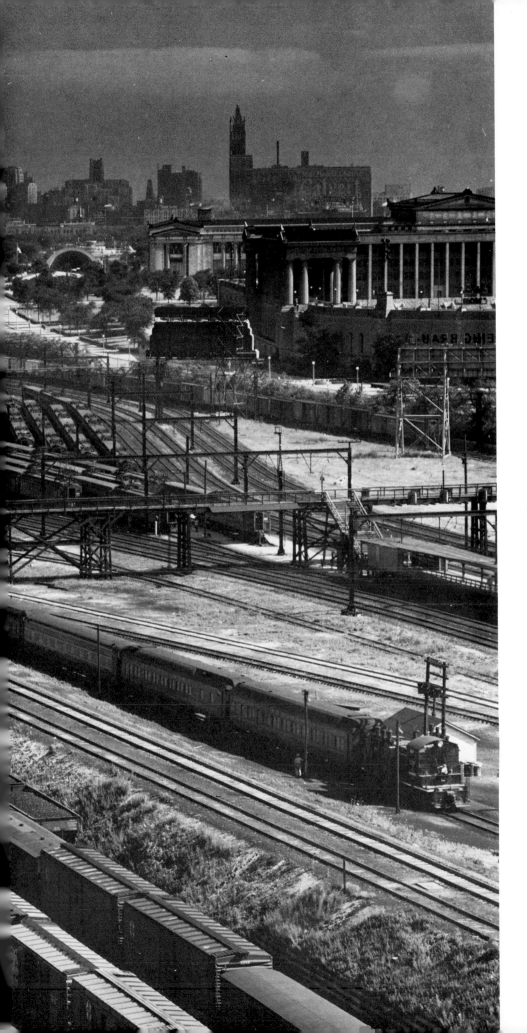

Illinois Central Railroad yards.

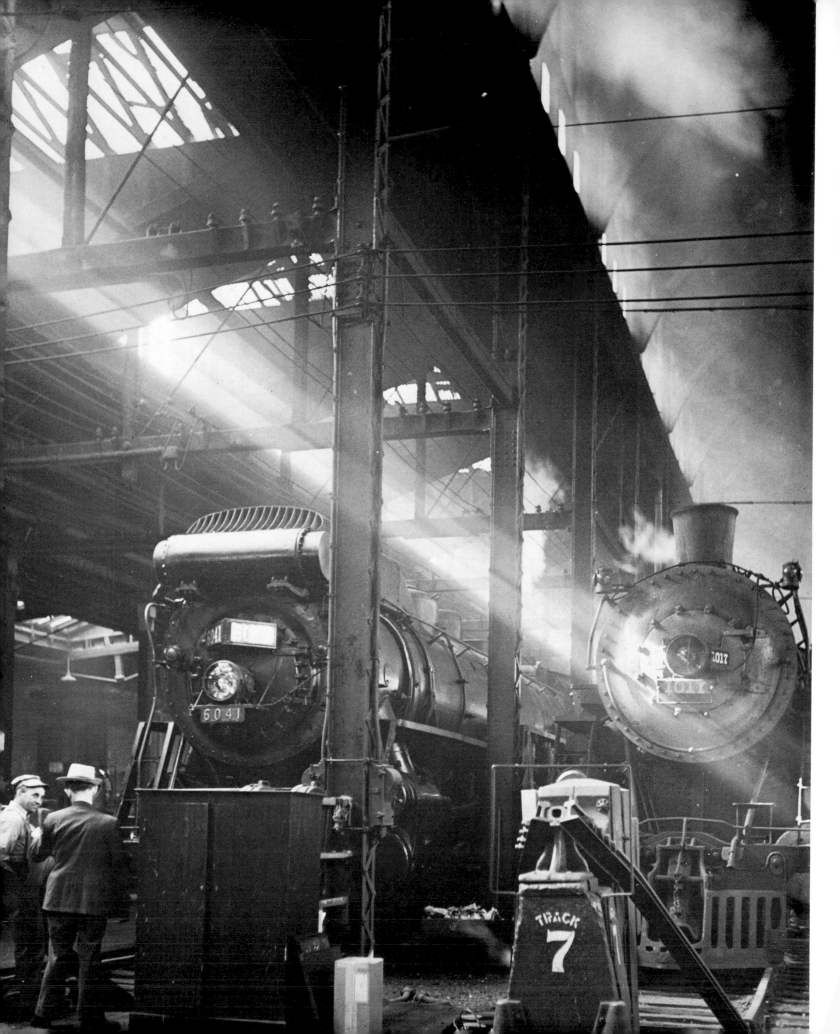

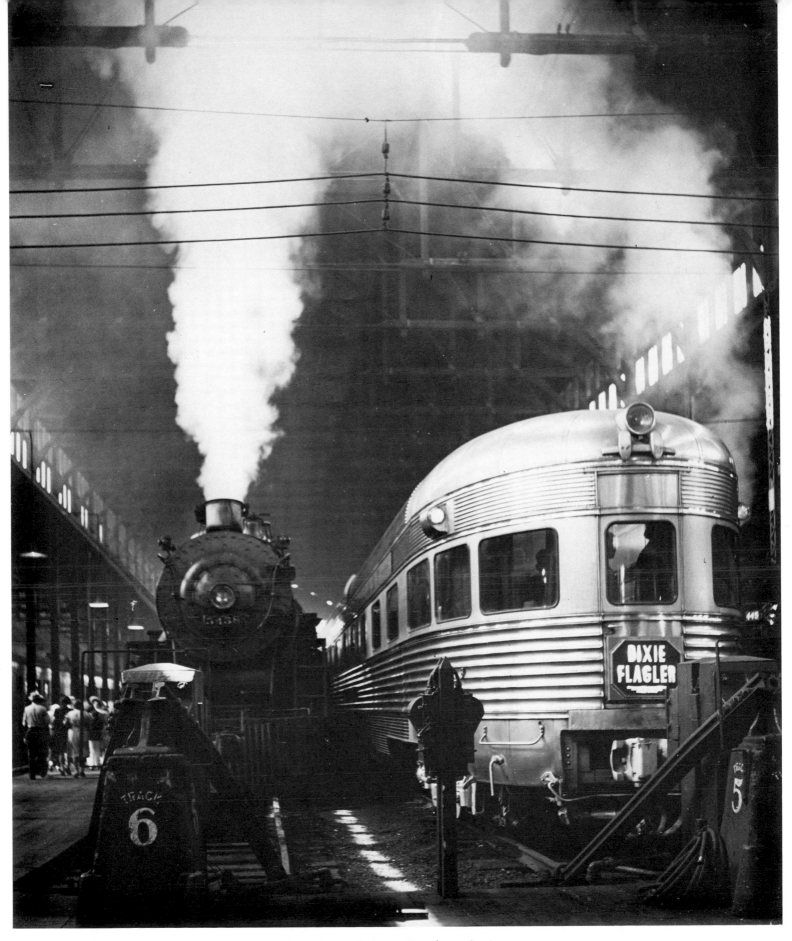

Opposite and above: Dearborn Station.

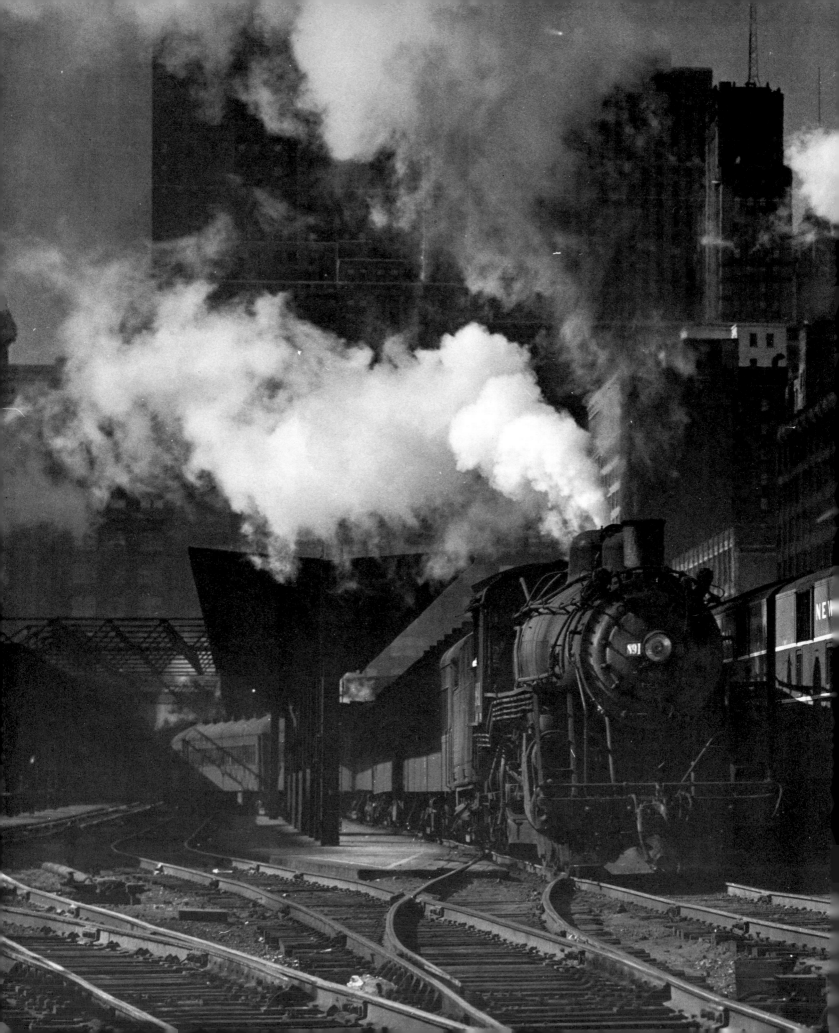

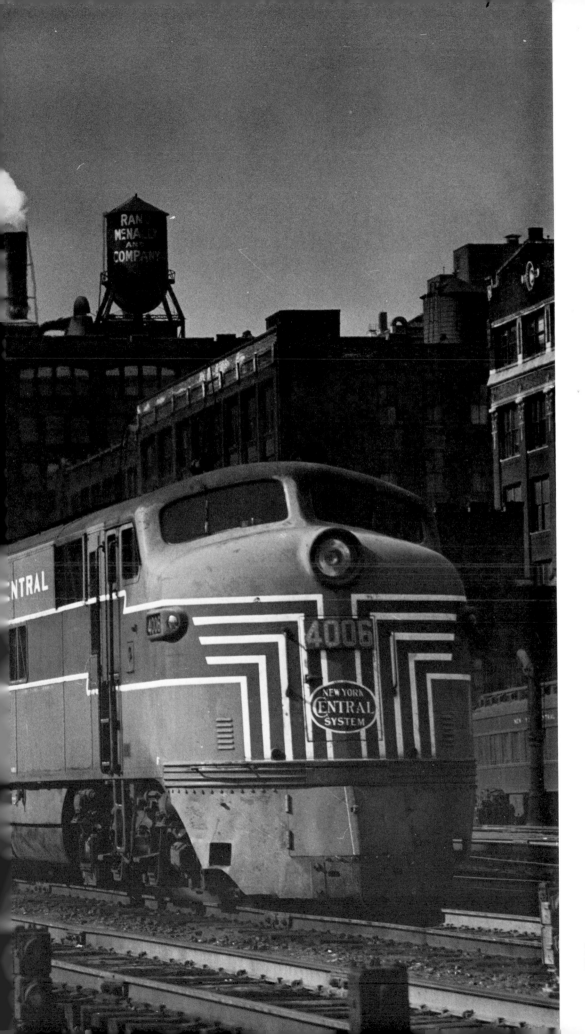

New York Central trains at La Salle
Street Station.

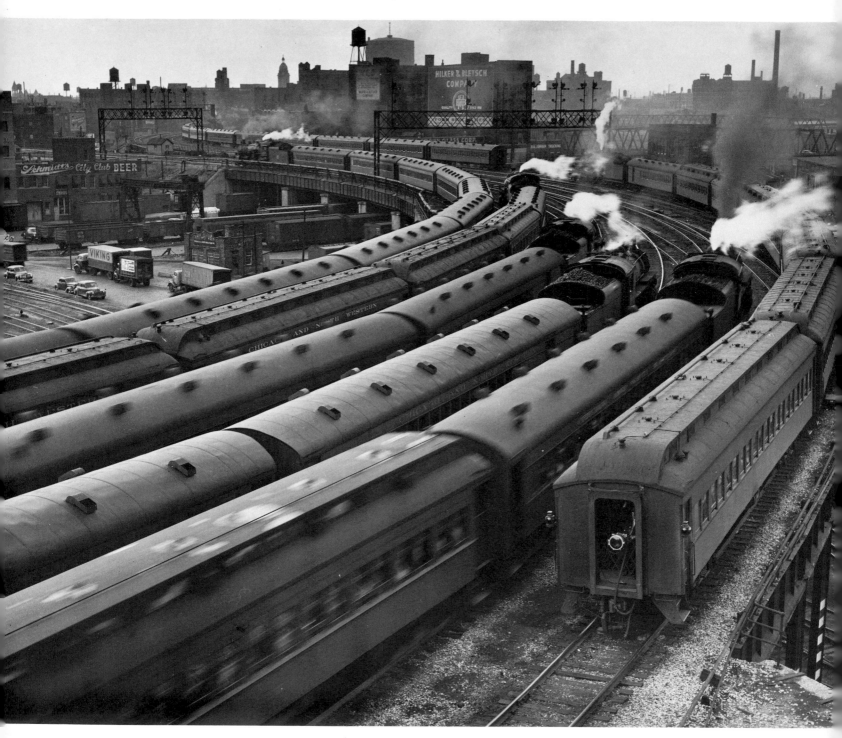

Above: Commuter trains, 5:00.
Opposite: Chicago and North Western Terminal.

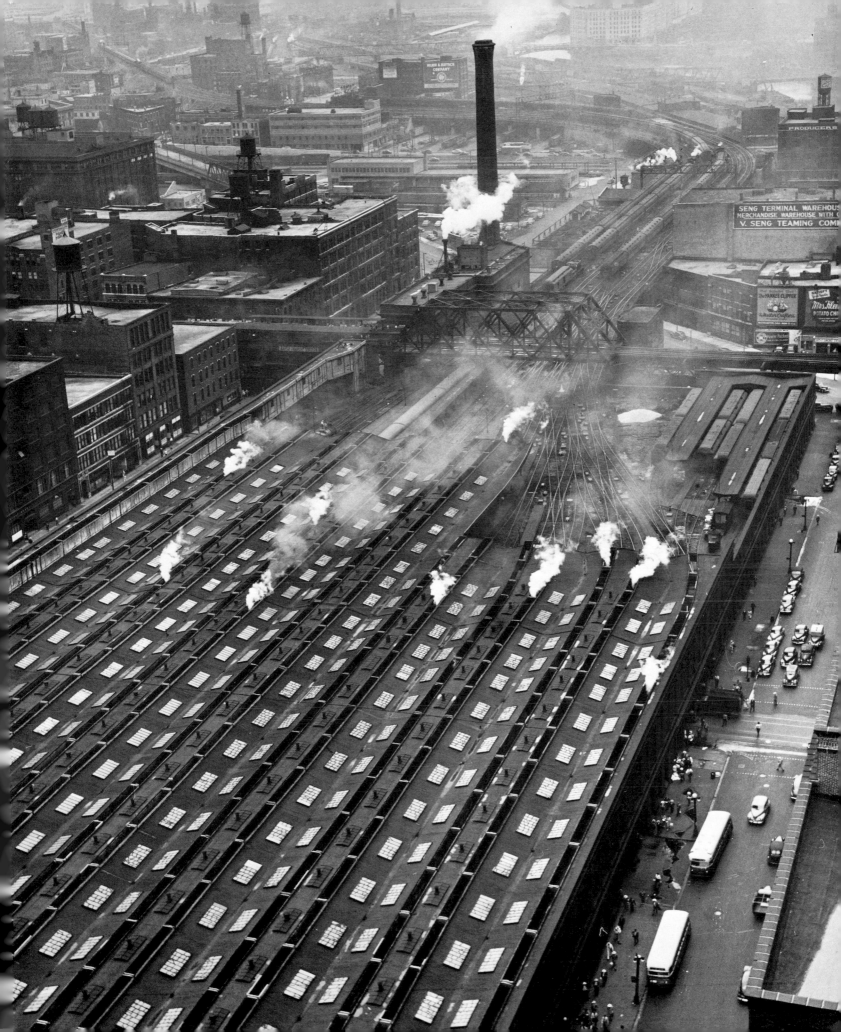

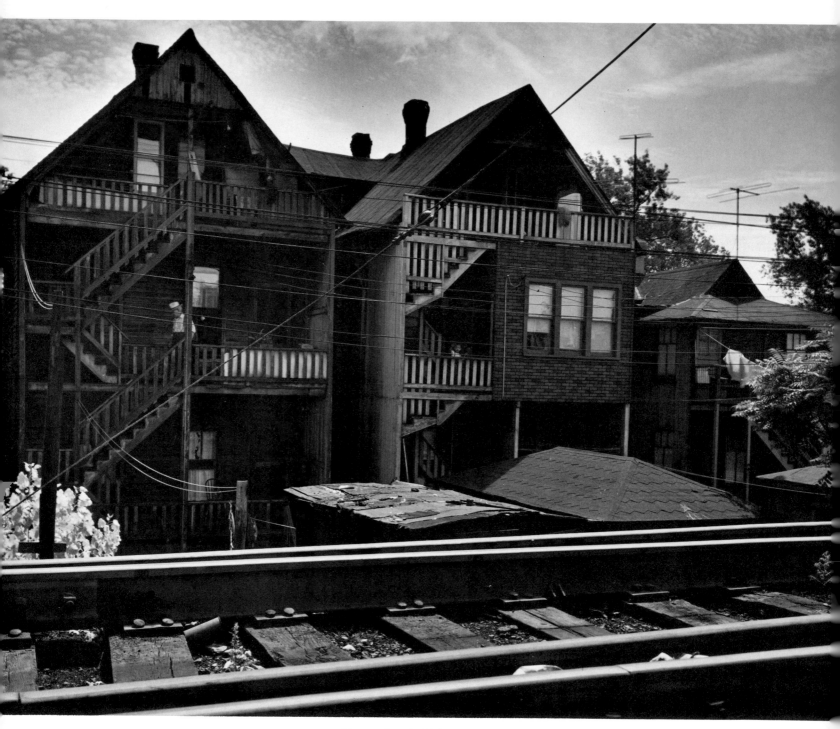

Above: South Chicago.
Opposite: In the roundhouse.

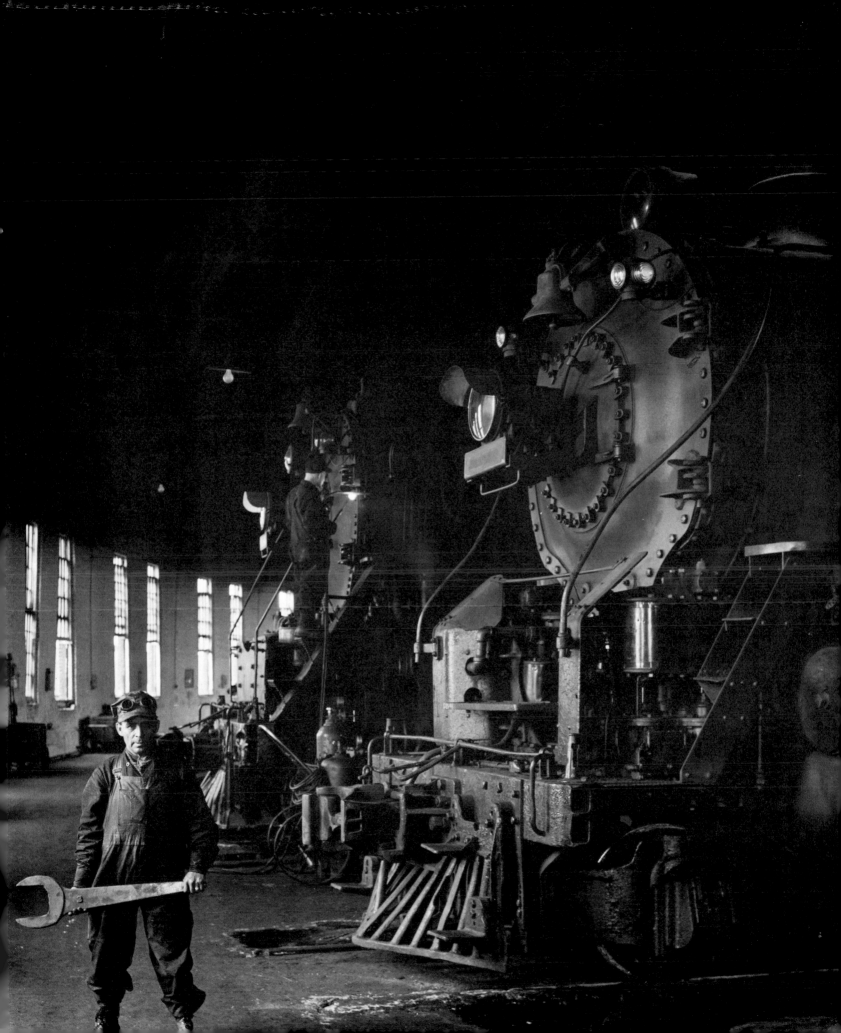

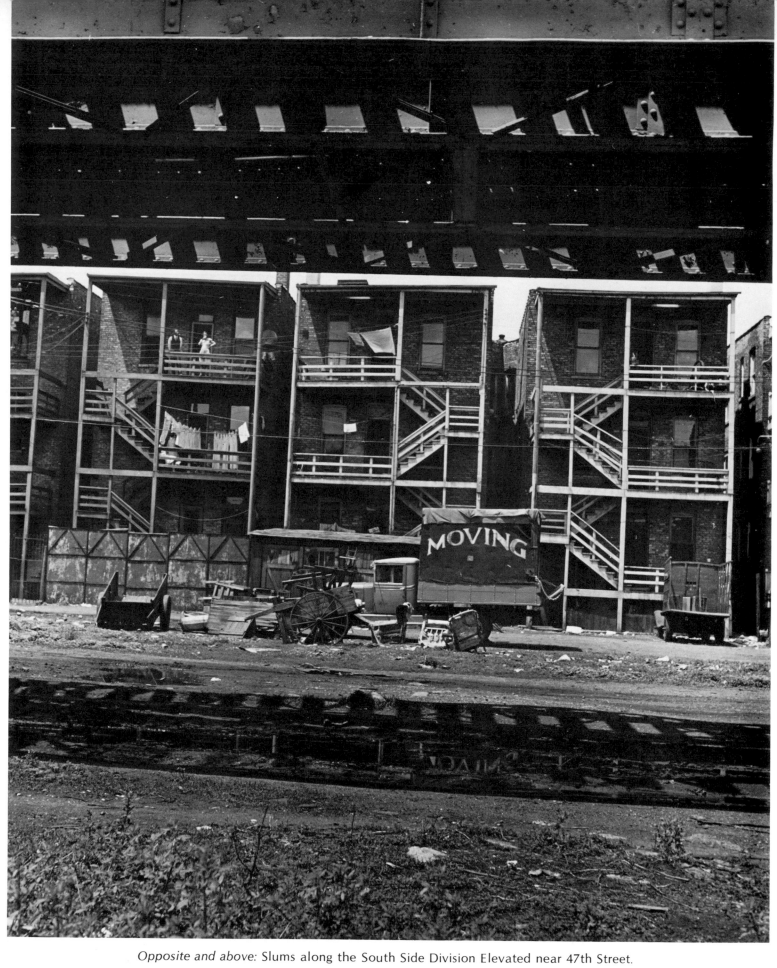

Opposite and above: Slums along the South Side Division Elevated near 47th Street.

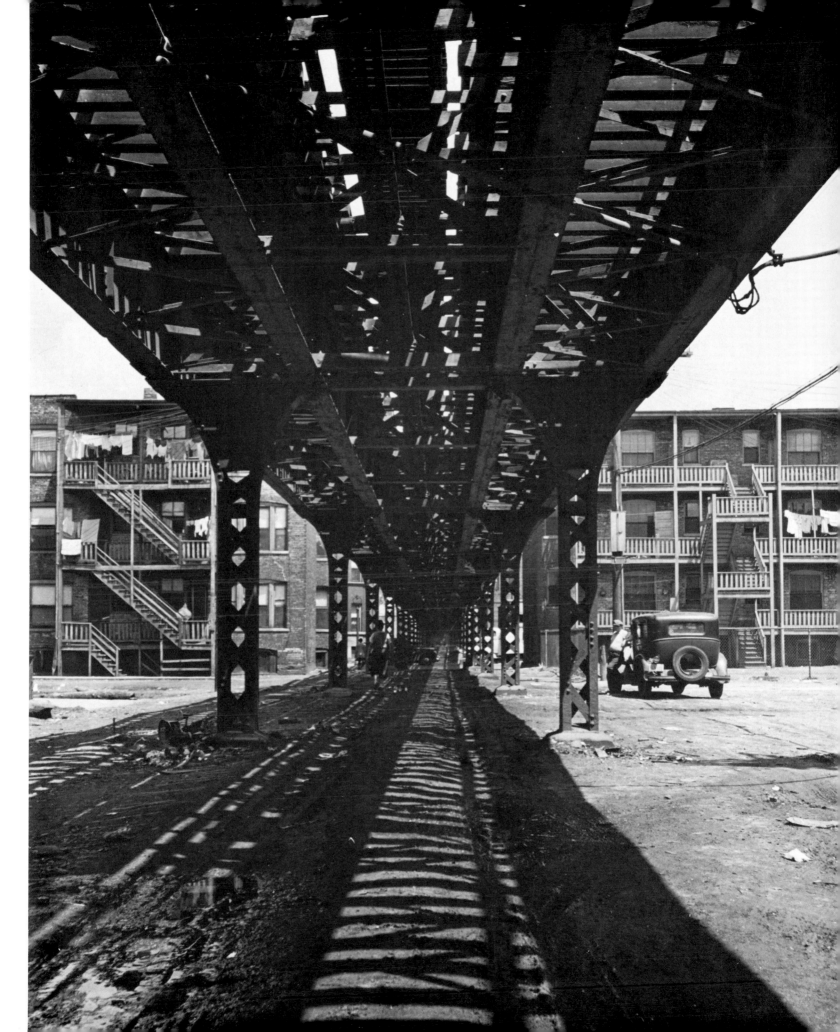

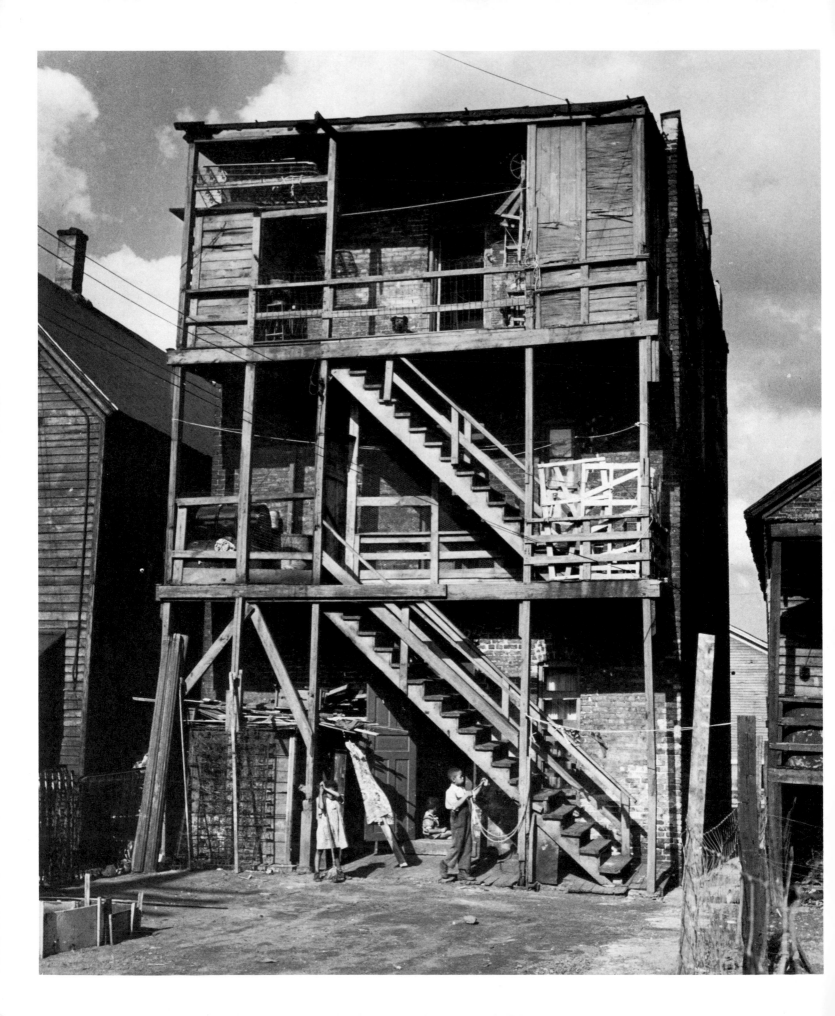

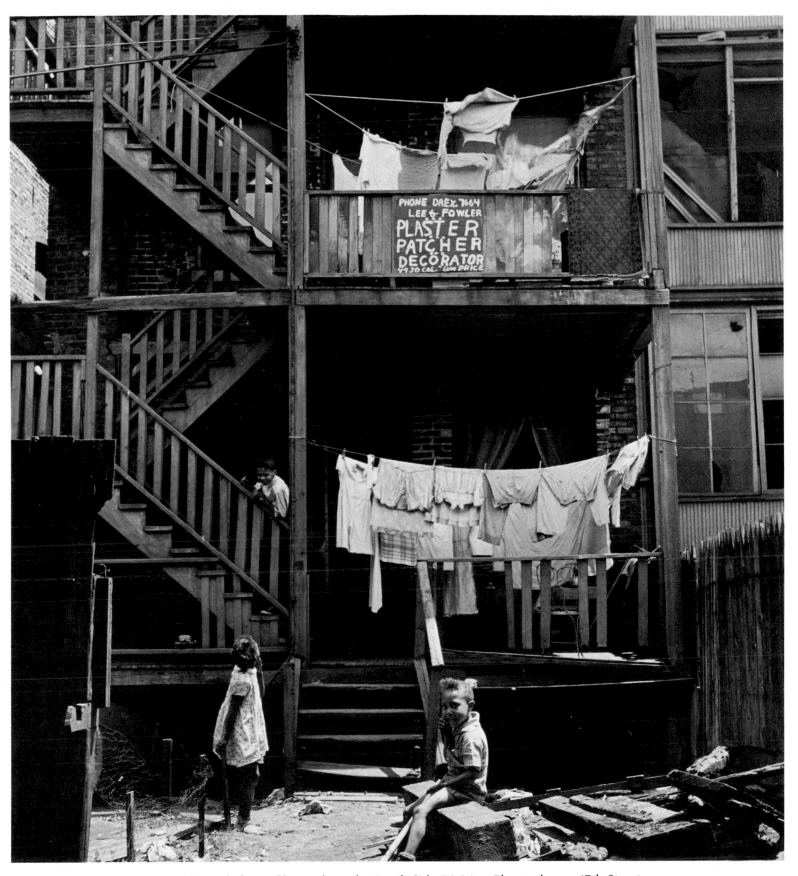

Opposite and above: Slums along the South Side Division Elevated near 47th Street.
Over: The "Golden Flats," South Side.

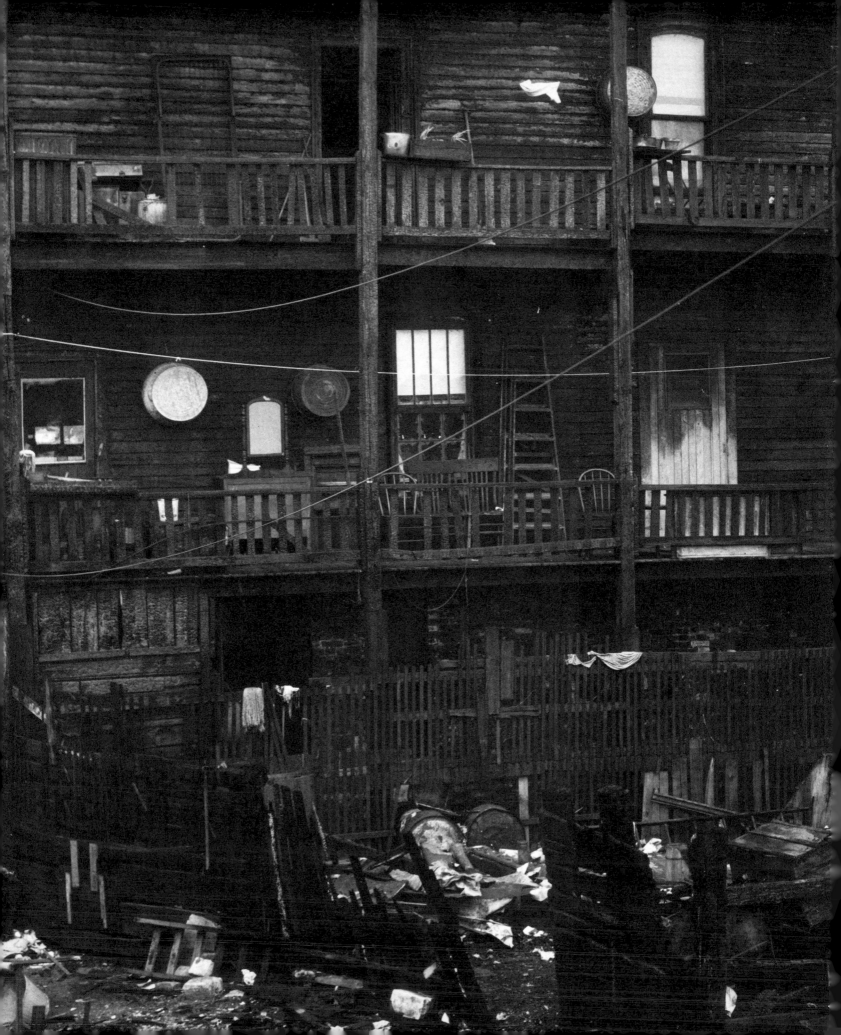

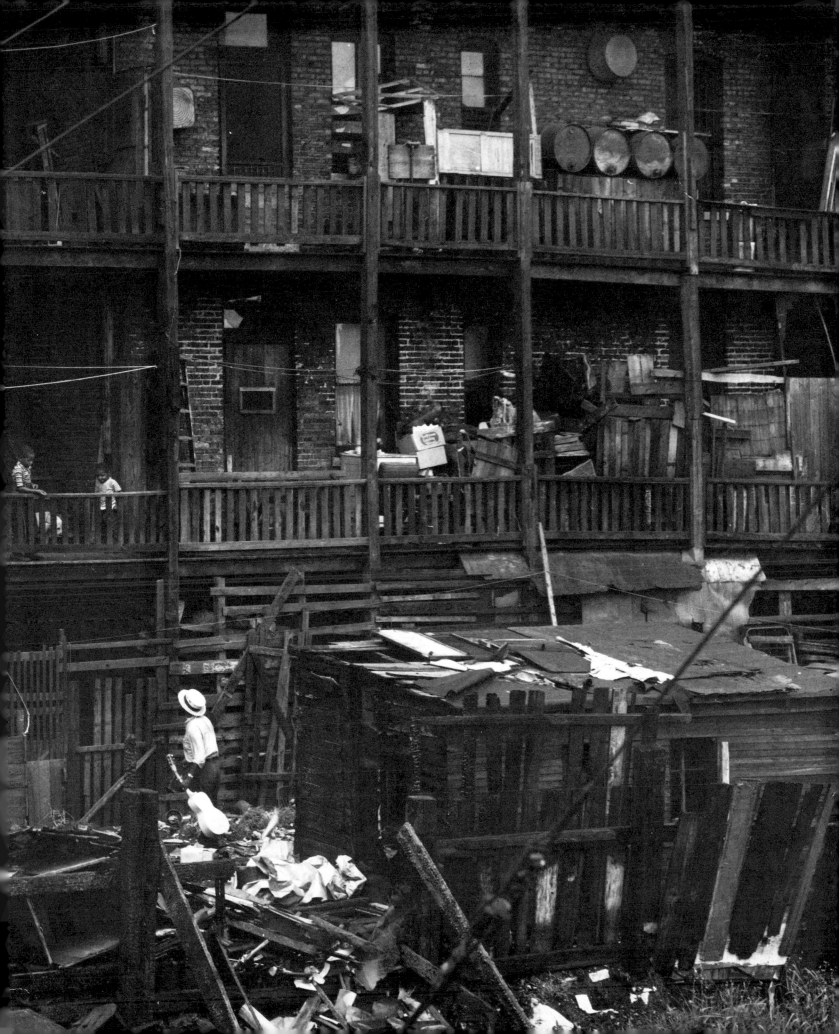

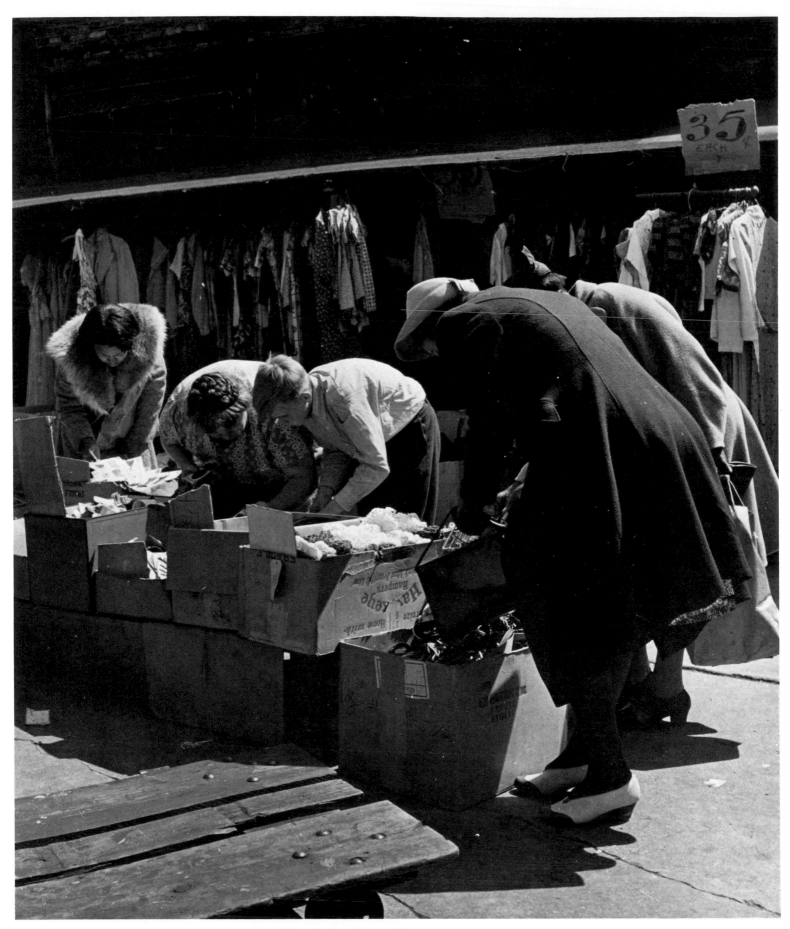

Ghetto Market, Maxwell Street.

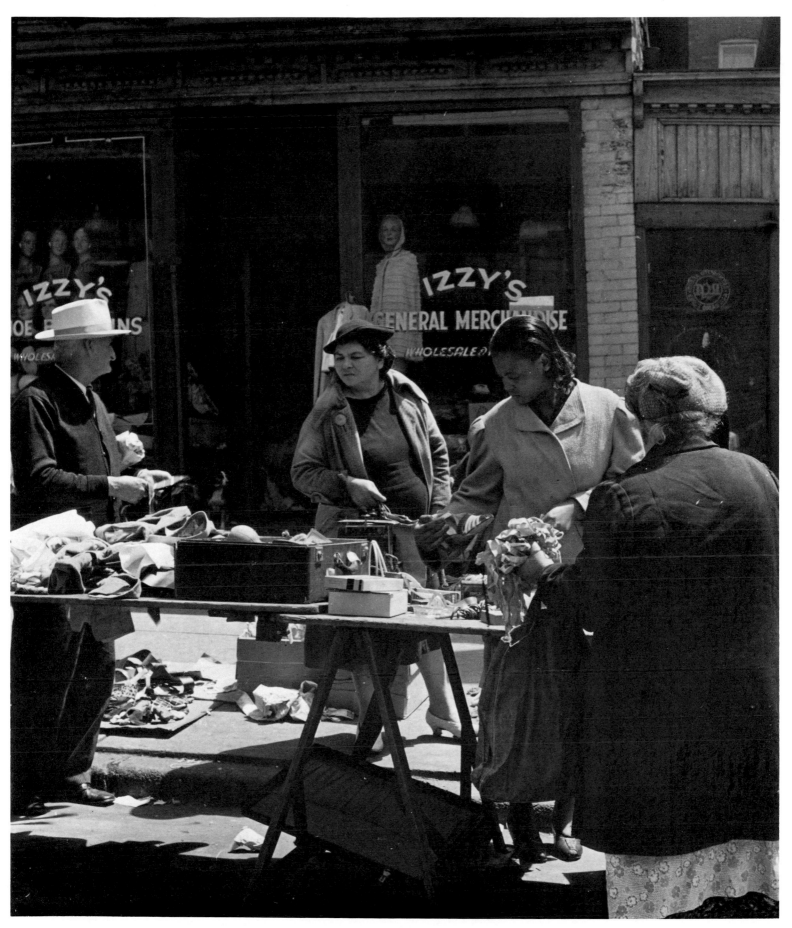

Ghetto Market, Maxwell Street.

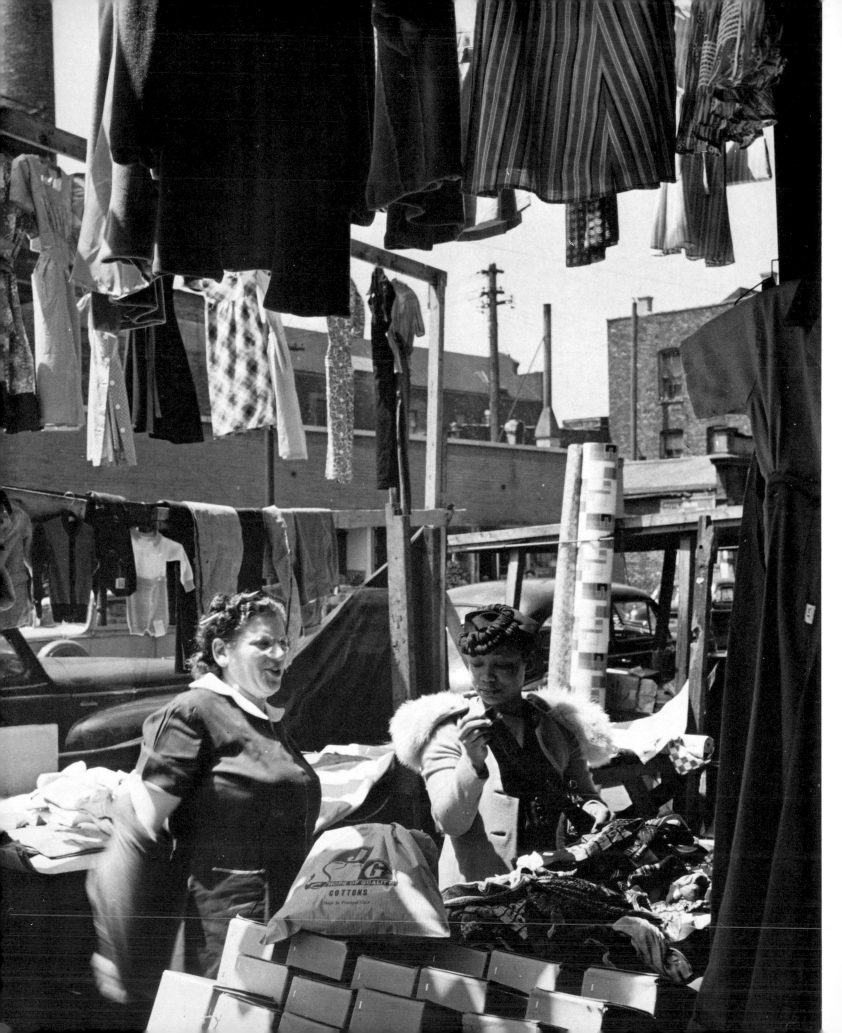

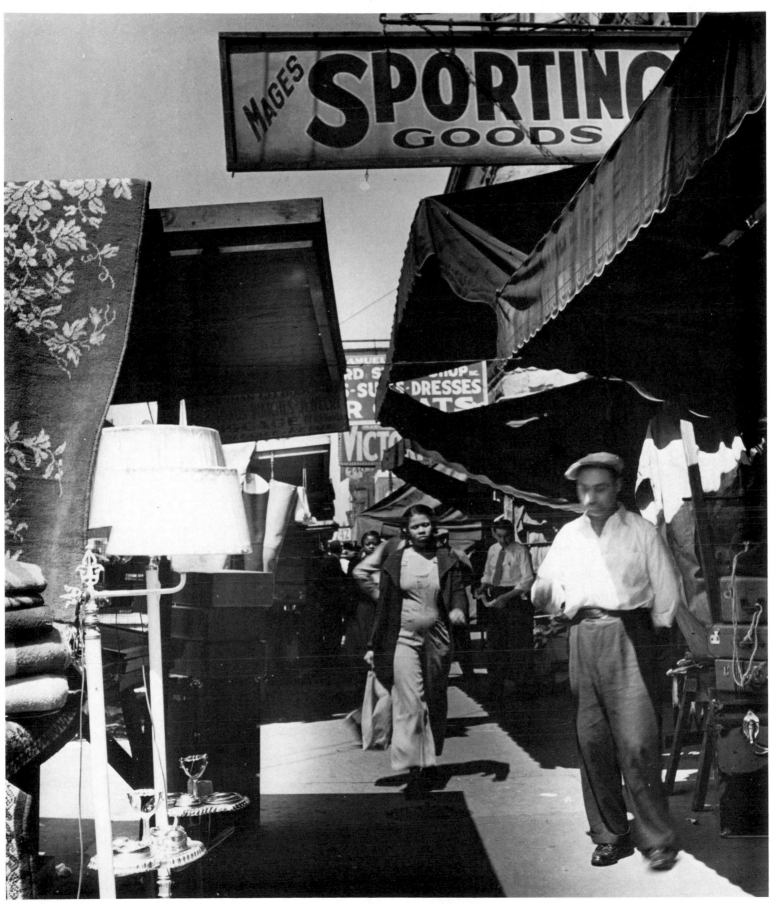

Opposite and above: Ghetto Market, Maxwell Street.

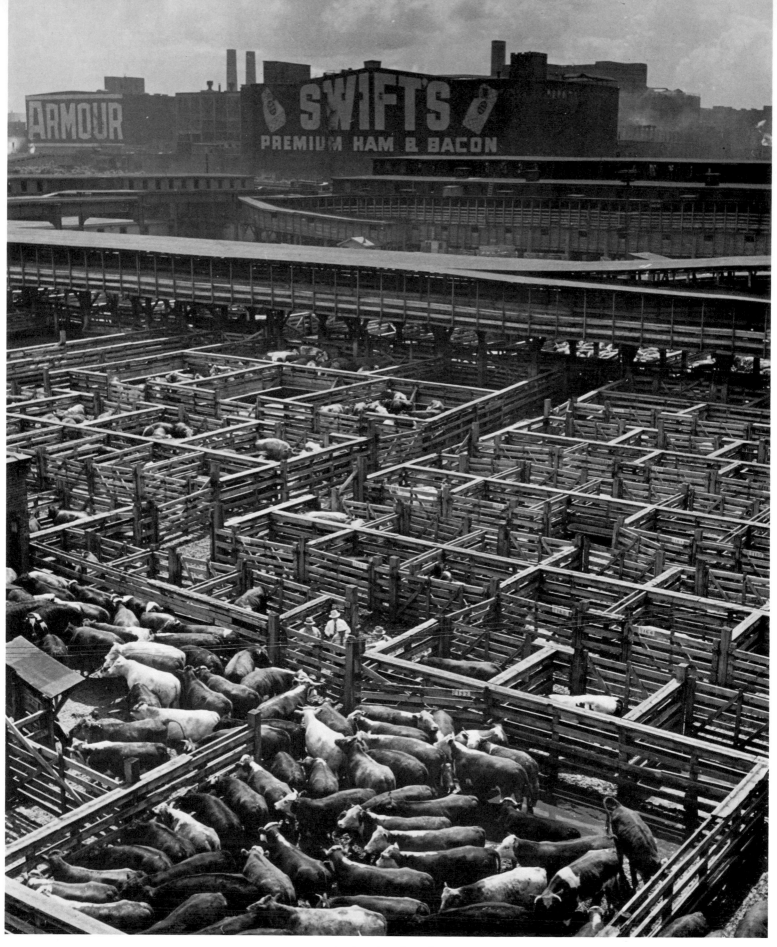

Union Stockyards.

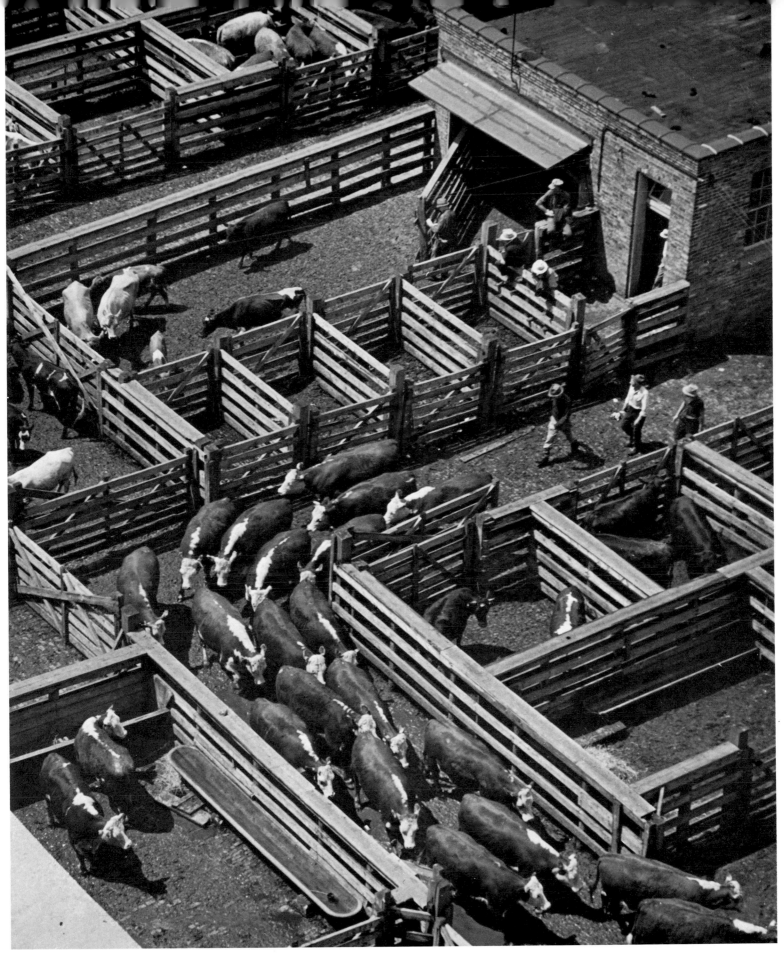

Union Stockyards.

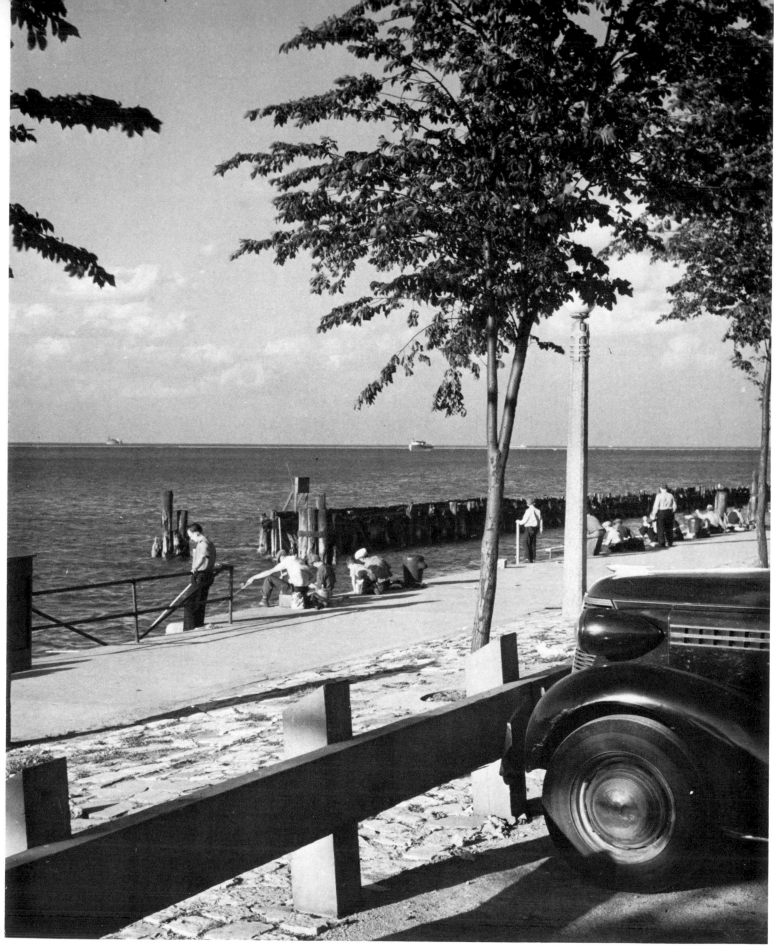

Oak Street Beach.

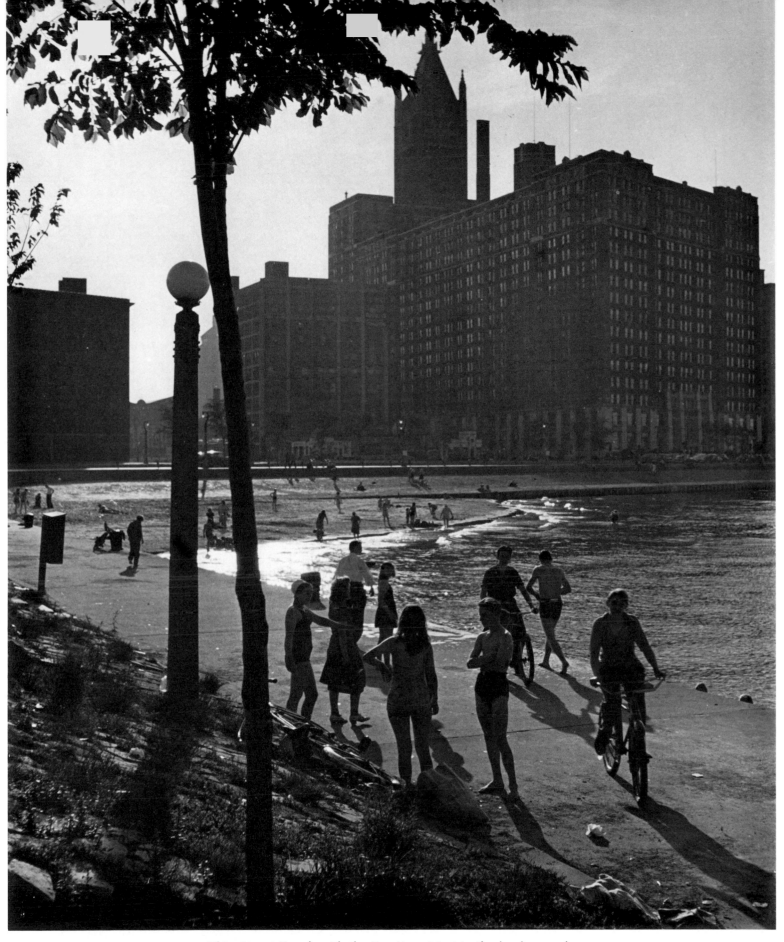

Ohio Street Beach with the Furniture Mart in the background.

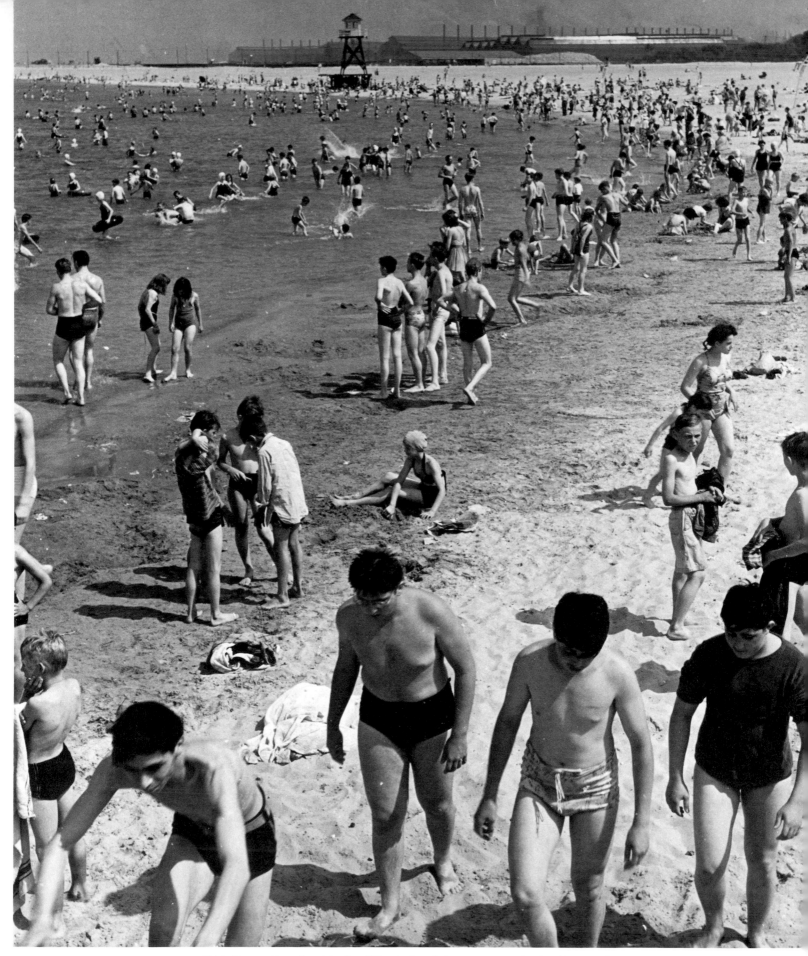

75th Street Beach with the Illinois Steel Company in the background.

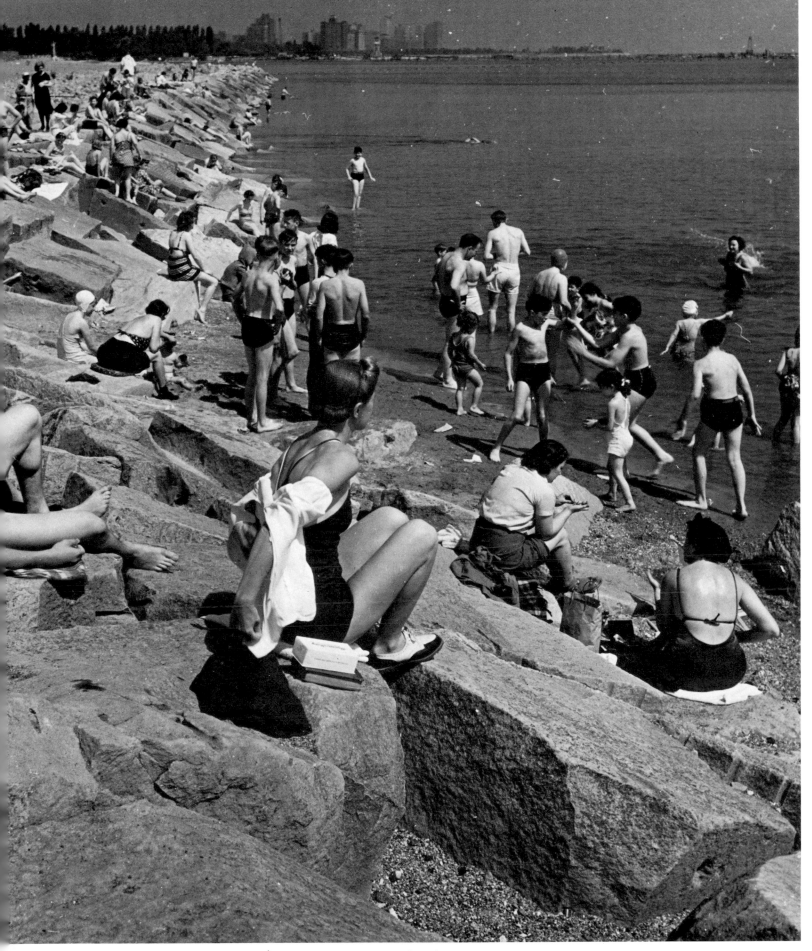

East End Park.